GRAPHITE

CONCEPT DRAWING | ILLUSTRATION | URBAN SKETCHING

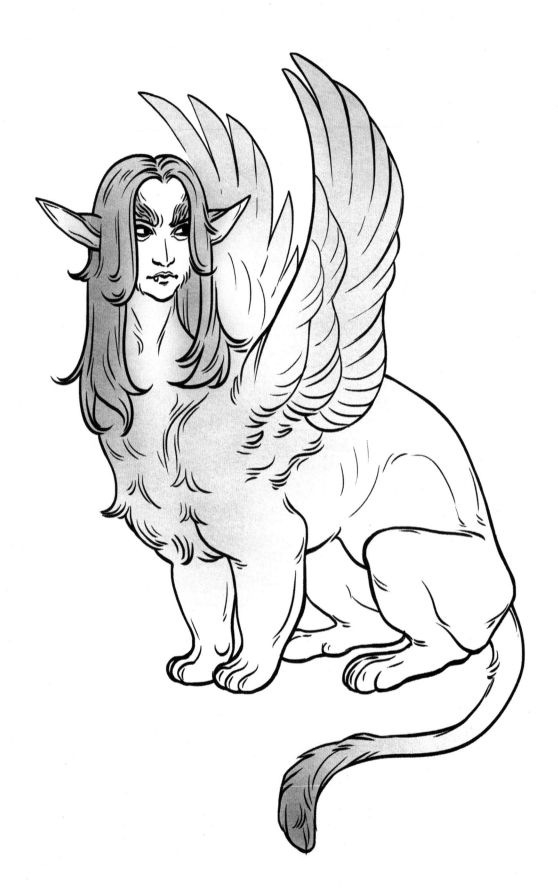

EDITOR'S LETTER

Welcome to issue 08 of GRAPHITE! This issue marks the completion of our second full "year" as a quarterly publication, and we hope you're enjoying the ride, whether you're a recent subscriber or have been with us from the beginning.

As always, we have brought together articles and artwork by a range of unique and talented creators from around the globe and across many different fields of art. We are delighted to feature the artwork of Allen Williams on the cover of this issue, with more inside from this master of the macabre. You will also find contributions by brilliant artists such as Anand Radhakrishnan, Nikolay Georgiev, Ashly Lovett, Ulksy, and many more besides, covering subjects ranging from mechs and dragons to life drawing sessions.

We are full of exciting ideas to continue improving and developing GRAPHITE, and can't wait to jump feet first into the next year of it. We hope you join us again soon!

Marisa Lewis
Editor

WHAT'S INSIDE

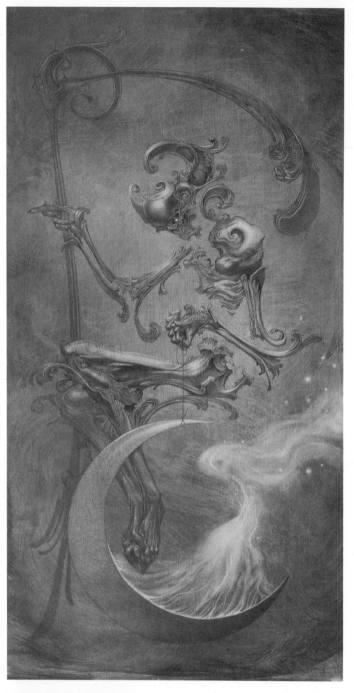

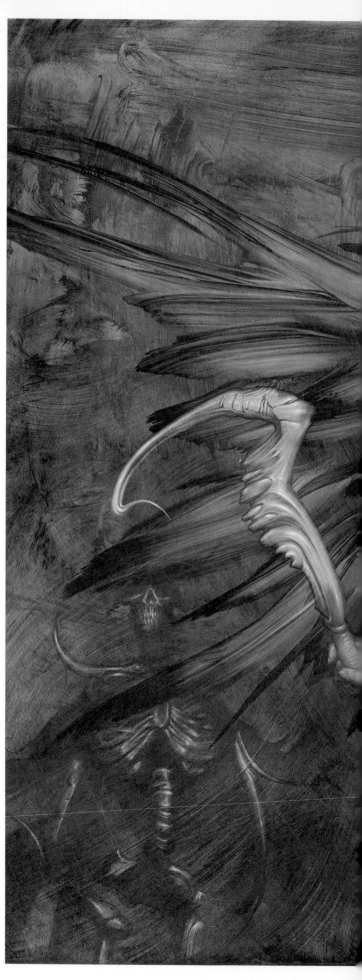

"This doesn't
mean that I find
stereotypically
beautiful works
to be invalid...
just one side
of the story"

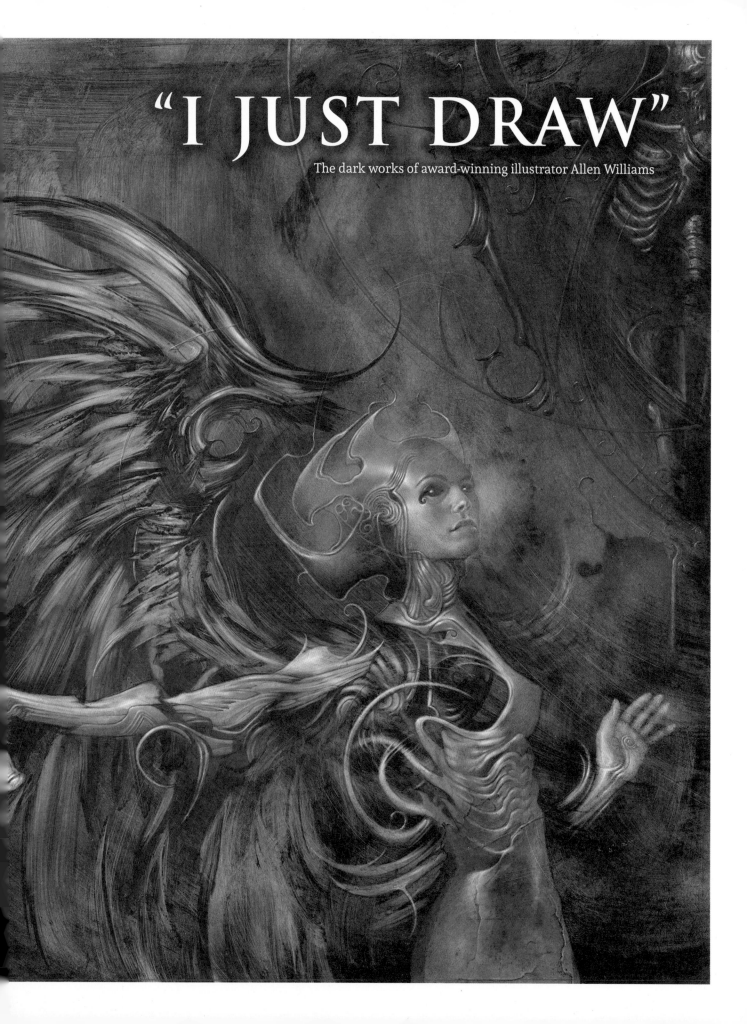

"I JUST DRAW"

The dark works of award-winning illustrator Allen Williams

Allen Williams currently works as a concept and creature designer for film and television, and is a fine artist working on the Gulf Coast. His first art book, *The Book of Covenants*, will be launched on Kickstarter in spring 2019.

Q· What themes or ideas do you enjoy exploring in your work?

A· I do a great deal of organic exploration and "found form" exploration in terms of my process. Within my work, I like to challenge the notions that beauty equates to goodness and the grotesque is predetermined to be wretched. We all know this not to be true, yet many fall into the same trap when creating their work. The challenge is often to make the image both compelling and repellent in a way that makes the viewer more deeply engage with the work. This doesn't mean that I find stereotypically beautiful works to be invalid... just one side of the story.

Q· What do you think is the biggest change to the industry landscape since you began working professionally?

A· When I began working 29 years ago, digital art wasn't a thing. It has given voice to many who otherwise might not have been enticed to do art. The only real drawback is the inclination to work too fast.

In years past, the only way to get your work to art directors was to either mail it to them or pony up the money and get a booth at one of the larger shows. *That* is how I got work in the gaming industry; no email, no internet, and no social media.

I like the way things have turned, though. Now the challenge is to engage without falling into the limitless distraction of the world of images, information, and opinions that are available.

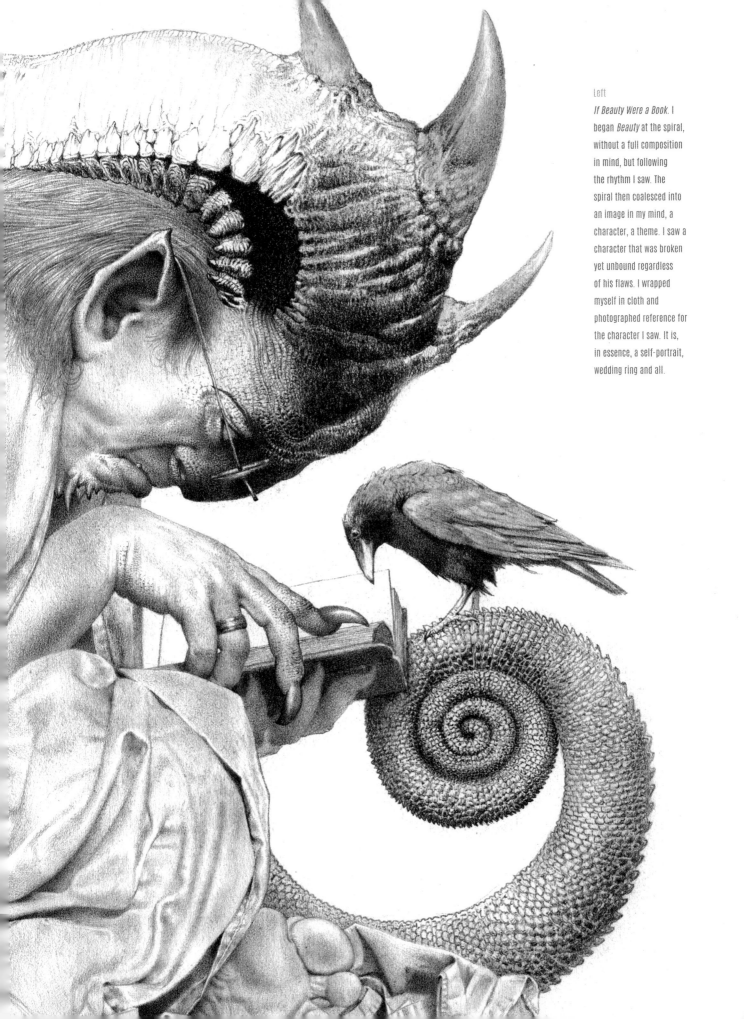

If Beauty Were a Book. I began *Beauty* at the spiral, without a full composition in mind, but following the rhythm I saw. The spiral then coalesced into an image in my mind, a character, a theme. I saw a character that was broken yet unbound regardless of his flaws. I wrapped myself in cloth and photographed reference for the character I saw. It is, in essence, a self-portrait, wedding ring and all.

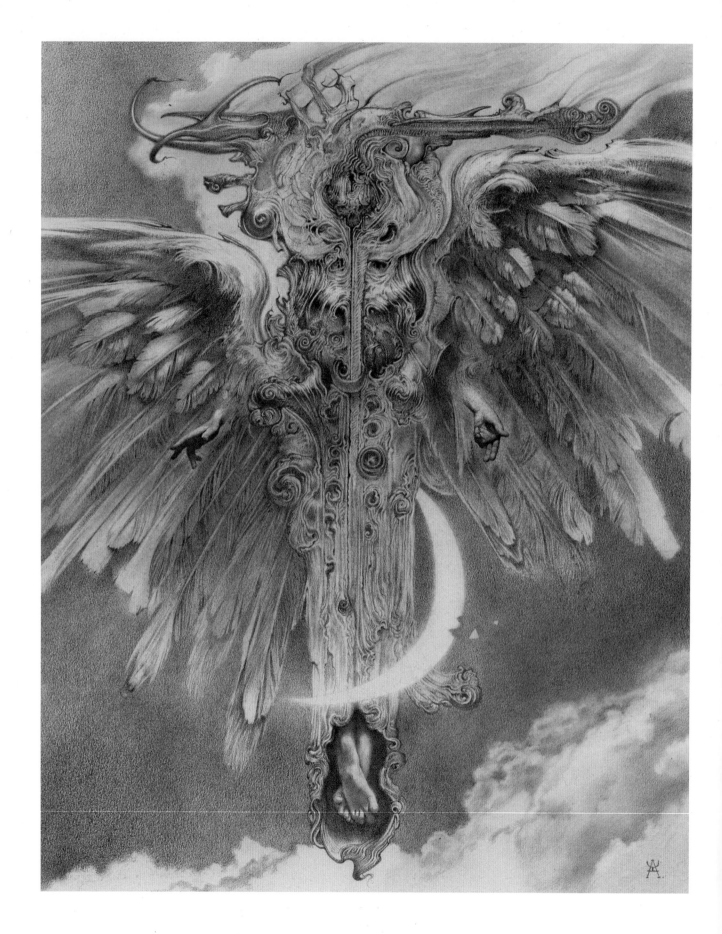

"When I began working 29 years ago, digital art wasn't a thing…"

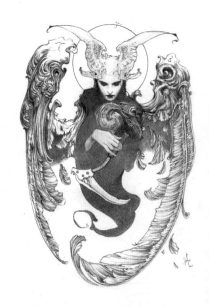

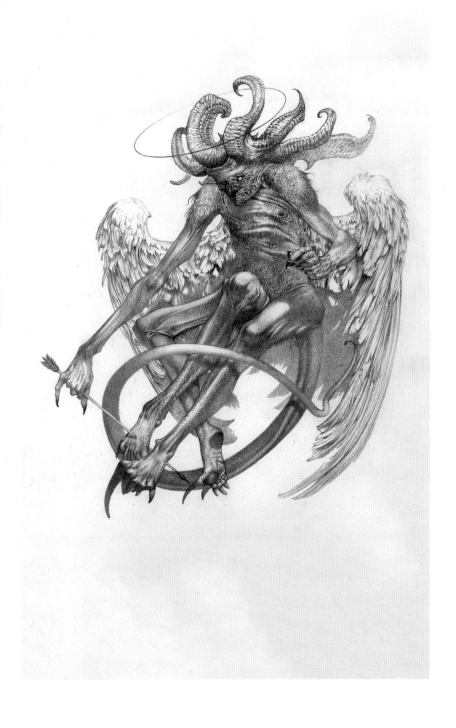

Left

Fall of Night
10" × 13" pencil on paper

Above

Hand of the Mother
9" × 13" pencil on Stonehenge Cream Journal paper

Right

Breath of Autumn
11½" × 14" pencil on paper

"Immortals, left to their own, could live forever,
but if one knew how, they could be killed.

Such a thing happened to Caith. Just three days ago, a
young man with a strong bow had sought her out ready
to make his name in the world by slaying a Harpy. He had
come upon her unawares and had let his arrow fly."

PASTEL PORTRAITURE

Portraits in hard and soft pastel with Ashly Lovett

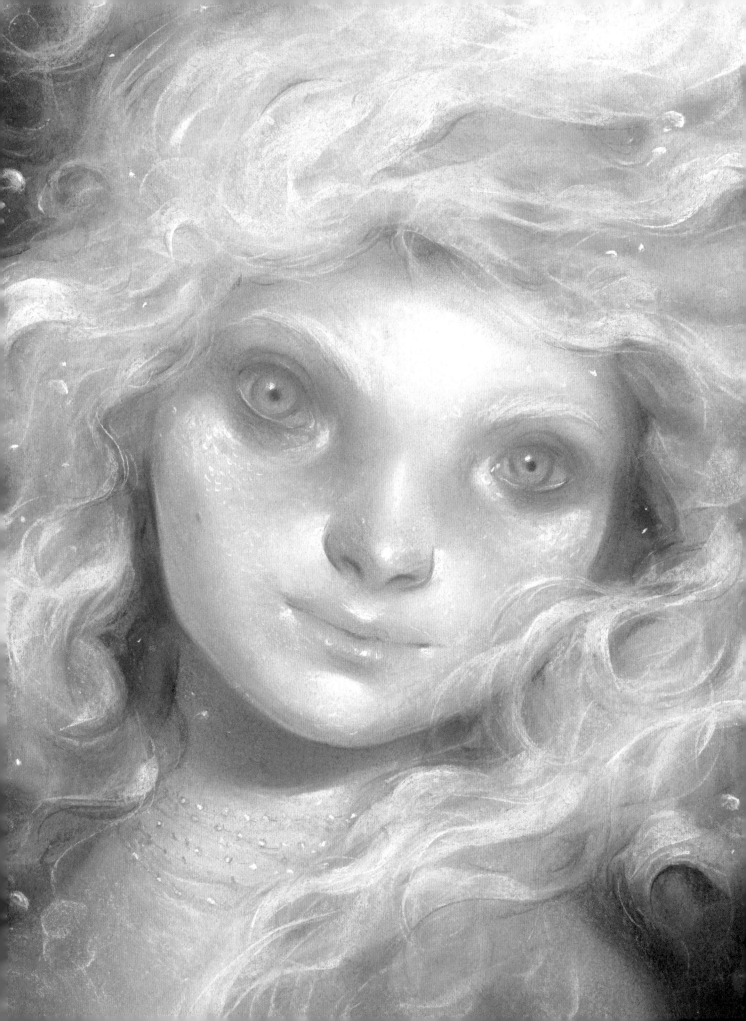

Illustrator and fine artist Ashly Lovett shares techniques for creating an ethereal portrait in the challenging medium of chalk pastels.

Left
Studio setup and
material preferences

Top right
Tools of the trade

Bottom right
Methods for blending
and creating edges

In this article I will create a chalk pastel portrait of a mermaid, as an underwater scene is ideal for depicting the various uses of the medium. The chalk pastel is not a popular drawing tool, and often artists struggle to control it; I think one common issue is not knowing which materials to use, so I will offer tips and guidance throughout this project.

Materials

I prefer to use Arches BFK Rives cotton rag printmaking paper, as the pastel dust clings to it instead of just sitting on the surface. I mount the paper onto a drawing board using Pro Artist Tape, positioning it upright so the pastel dust can fall downward. I use two clip-on lamps on either side to reduce the shadow cast by my hand. Having a bulb that is too warm or too cool can affect your color choices, so I advise using a natural daylight bulb which provides a neutral light. The pastels that I'll use are kept on a wire mesh tray that is lifted above my work area by a quarter inch. The mesh allows excess pastel dust to fall through, keeping my pastels cleaner for longer.

Drawing tools

I will use a mix of hard and soft pastels for this image. Prismacolor NuPastels are hard pastels, which are a bit less vibrant in color but do not crumble as easily. These are used primarily for fine details and edges. I use soft pastels by Koh-i-Noor and Sennelier to cover larger areas since they are much softer. Other tools include a cotton rag, a can of compressed air to remove excess pastel dust, and an X-Acto knife to sharpen my pastels. My hands are my main tools, so I keep makeup remover wipes nearby for quickly cleaning them. Lastly, a face mask is very important, as some pastel brands are toxic if inhaled over a long period of time.

Blending methods

Pastels offer two blending methods and three types of edges. The *direct* method is applying the pastel with little to no blending; this offers stronger contrast and is bold against the paper grain. The *blending* method is what you would use throughout most of an illustration, creating smooth transitions to suggest form. You can also use a cloth for even smoother blending. In terms of edges, pastels can create a hard edge for bold, interesting strokes, a rounded edge for blending, or a line edge to add very sharp contrast.

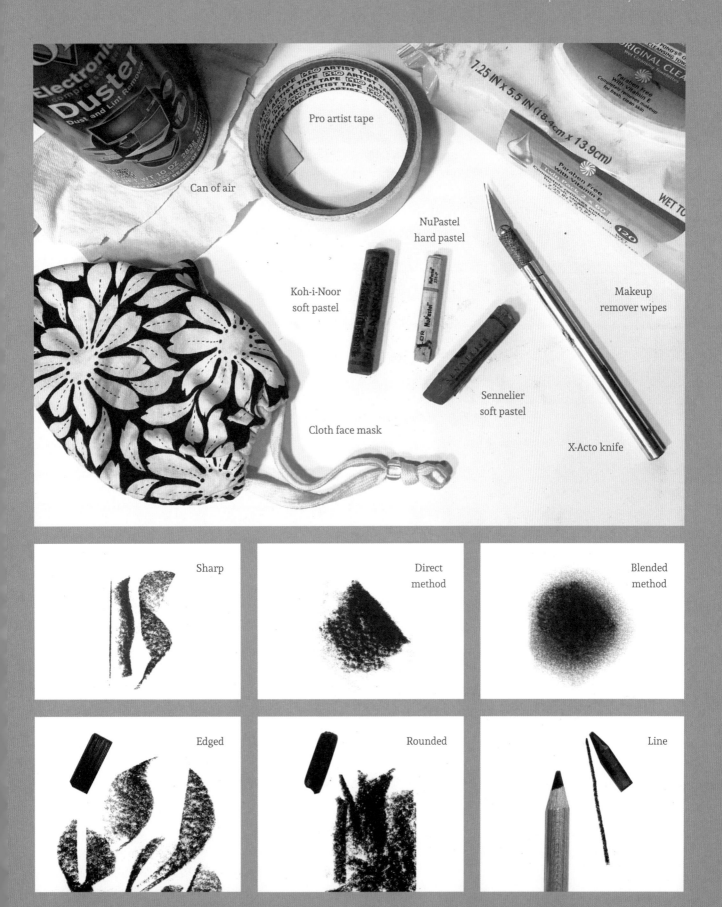

Can of air

Pro artist tape

NuPastel
hard pastel

Koh-i-Noor
soft pastel

Makeup
remover wipes

Sennelier
soft pastel

Cloth face mask

X-Acto knife

Sharp

Direct
method

Blended
method

Edged

Rounded

Line

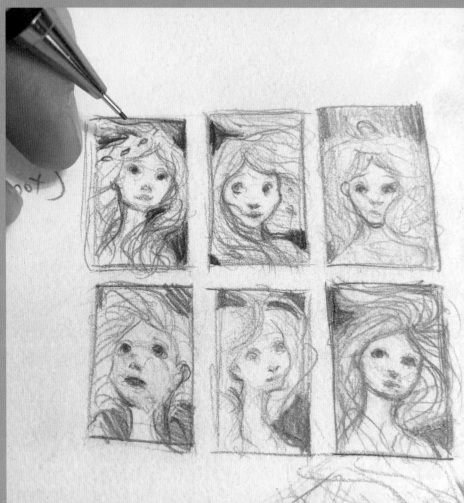

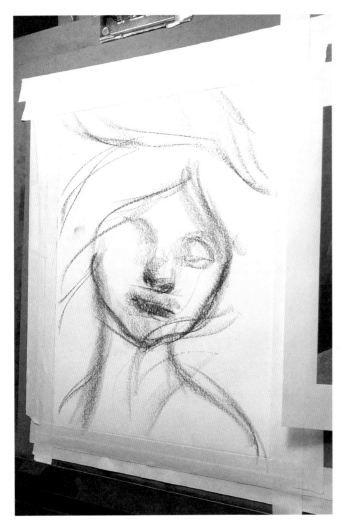

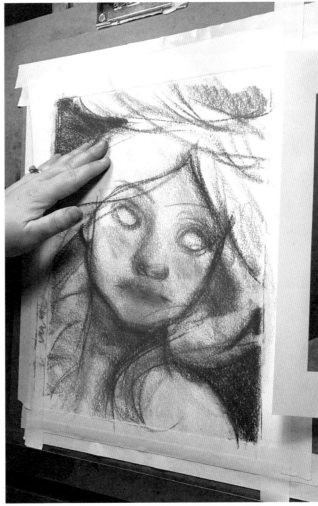

Thumbnails and studies

Thumbnail sketches are supposed to be small, forcing you to think about the overall picture and not the details, focusing on finding shapes that make the most interesting composition. I want to showcase a portrait with flowing hair, so I explore S-shaped compositions, and choose the thumbnail that best gives the impression of being underwater versus my character's hair blowing in the wind.

I also make some small, simple color studies on BFK Rives paper, choosing the middle color palette for my final image. It has the most depth and a strong underwater feel.

Base sketch

I start all my drawings by establishing where the lips, nose, and eyes will be. I look up some reference to loosely use, to help understand and define the facial features. It is possible to transfer a base sketch to the mounted paper using graphite transfer paper, but for this particular demonstration, I prefer to work directly on the final paper with a dark pastel.

Applying midtones

Once I have established a loose drawing, I start to put down my midtones. I use quite vibrant colors in the beginning, applying deep blues to the background and warm hues to the cheeks and lips.

These vibrant colors will show through as I build up the layers. When there is enough pastel covering the paper, I smudge everything to create an even tone to work with, getting the pastel into the paper grain.

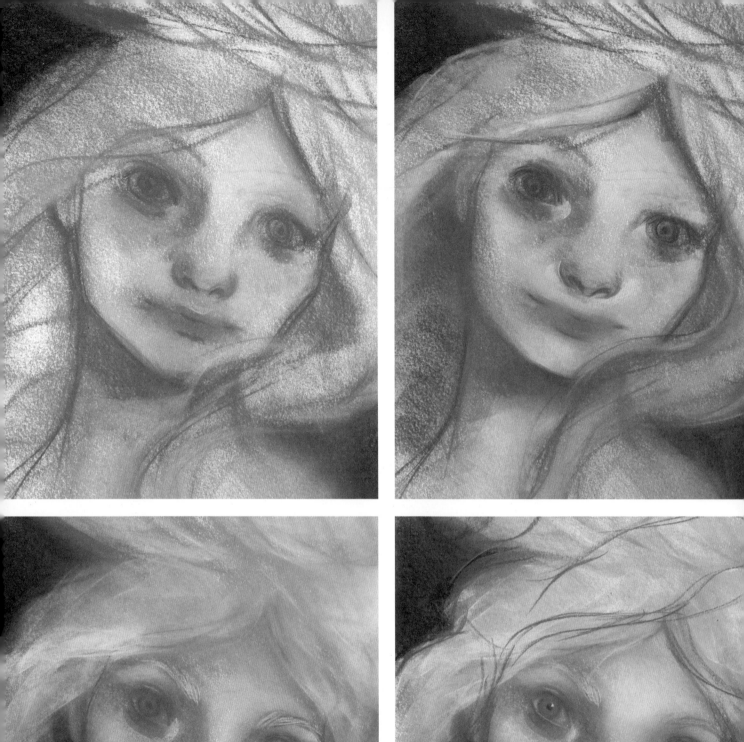

Far top left
The midtones after all the colors have been blended and smudged

Near top left
Defining the forms by adding lighter values

Far bottom left
Continuing to define the forms and adding more color

Near bottom left
Developing the forms and defining the hair

Right
Hair studies in gouache

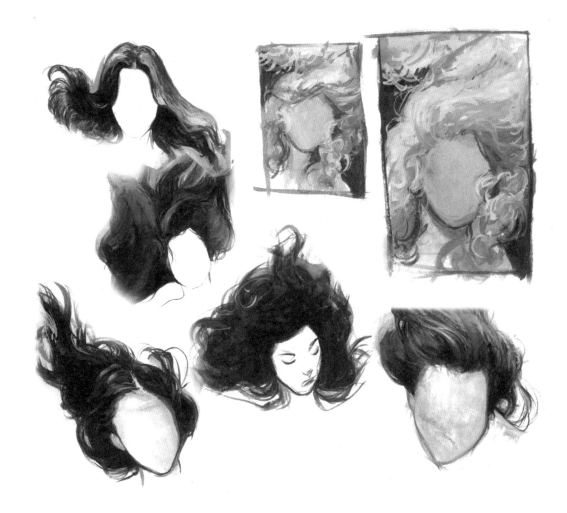

Building up values

I continue to build up the drawing while keeping in mind the colors and S-shaped composition I defined in my studies. To achieve this flowing composition, I want to keep the negative space on the top left and bottom right very dark. This piece will have "high key" lighting – very brightly lit, with few deep shadows – so my darkest areas will be crucial in defining the value scale of the image. These will be my darkest darks and help to define my lightest lights.

Light and contrast

Once a general midtone is established, I start adding lighter tones. These areas are where light is hitting the surface of the face, so I check my references to help define these forms. I consider the reference material as a road map and keep in mind where the light source is coming from. At this stage I also apply harder edges to create contrast, using the sharper drawing techniques shown in the "Blending methods" step, as the viewer's eye is always attracted to contrast.

I continue to build up layers in the hair and skin, defining my forms and applying more stylistic choices, such as her otherworldly, far-apart eyes. Her cheeks are now more pink and alive, and her eyebrows are roughly sketched in with a fine edge.

Evaluating progress

I apply rim lighting along the chin to accentuate the sense of form. The face is looking more fully developed, but I pause to reflect on my progress. After adding highlights to her eyes, I decide I want to adjust them and make them lighter. I also want to practice how I will approach her hair. Making revisions in pastel can be very daunting, but is not impossible, as we will cover.

Underwater references

I search online for reference images and videos of "underwater fashion." I choose references that aren't necessarily perfect silhouetted shapes, but instead require working with subtle value shifts. Studying these gives me a clearer idea of how her hair would move. With this new knowledge, I plan out her hair shape in small thumbnails that still work with my S-shaped composition.

ARTIST'S TIP

Combining multiple scanned images

When you have to scan a large illustration in sections, use Adobe Photoshop's Photomerge function (File > Automate > Photomerge) to combine them into one complete image.

Storing and cleaning pastels

Store your chalk pastels in tackle boxes and fill them with uncooked rice. The rice will keep the pastels from rubbing against one another and becoming dirty. You can also clean your pastel sticks by placing them in a lidded plastic container full of rice and shaking it.

Paper choices

Stonehenge is another brand of cotton rag paper that I recommend. I like cotton rag paper because of the tooth (surface texture), and also because it can be submerged in water and not warp when dry again. This can lead to fun experimentation with mixed media.

Mirror your image

Seeing your illustration mirrored or turned upside down is a good method for critiquing its progress. Download an app that allows you to flip photos, or scan your image into Adobe Photoshop, or use a mirror to spot any potential errors that may need correction.

Making revisions

As much as I like the individual areas of my drawing, such as the lips and eyes, other areas do not work as well for me. I wipe the piece down with my hand and a cotton rag, use the can of air to remove excess dust, and continue working up from the "ghost drawing" left behind. I do this a lot when working, and I think my pieces benefit from the history left behind. When working on any kind of drawing, never try working around a problem just because you have one great-looking eye! Don't be afraid of destroying your piece to find something better. On the near right, you can see how I have incorporated a new hair shape, based on my studies, and continued to build and blend the skin.

Highlighting the face

My favorite part of a portrait is adding the highlights to the eyes. Little details like highlighted lips and hair strands are another satisfying touch, using the edge of the pastel to achieve crisp detail. I constantly look back at my hair thumbnails and color studies to keep everything in line with those values and colors. I would always advise staying true to your studies and early process work; you made those drawings to solve problems before beginning the final image, so stick to the plan!

Further detailing

At this stage I often reapply strokes until they look interesting and "effortless," though this honestly involves a lot of trial and error! I also usually scan my drawing and look at it in Adobe Photoshop, where I can flip the artwork horizontally to see if any adjustments need to be made. Now only a few last details are needed to tie the image together.

Finishing touches

I add some harder edges within the hair to bring the character forward. I apply highlights to her necklace and lighten the whites of her eyes, and add scales to her cheeks and bubbles to push the underwater narrative. Rim lighting is an excellent tool to show form and make a character look more finalized; you can see where I have added a subtle rim light on the jawline to round out her face and make the scene's lighting feel more complete. Last of all, I use the can of air to remove any excess pastel dust from the finished image.

Top near right
Reworking the drawing and building it up over the ghost image of a previous version

Top far right
Using highlights to develop the face and give it dimension

Bottom near right
The image is almost complete, but needs some finishing details

Bottom far right
The final image © Ashly Lovett

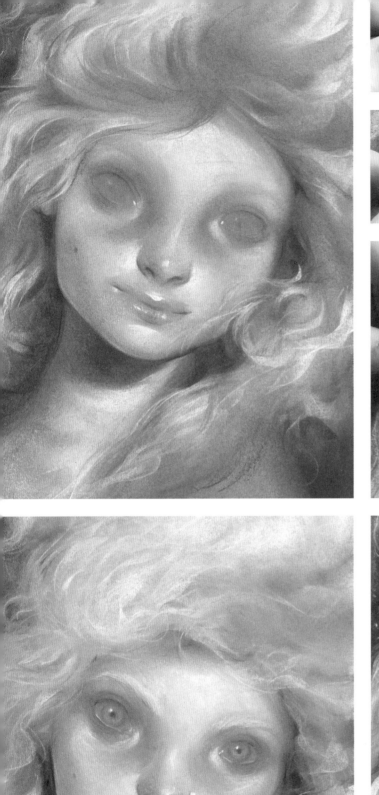
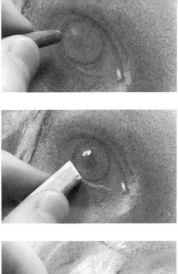

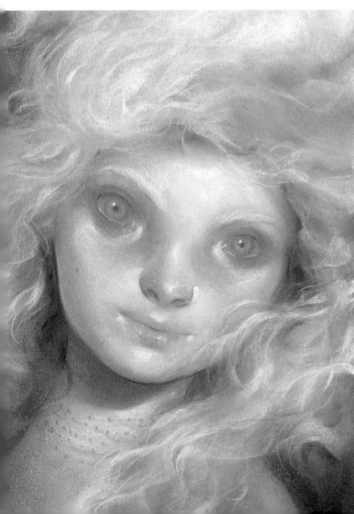
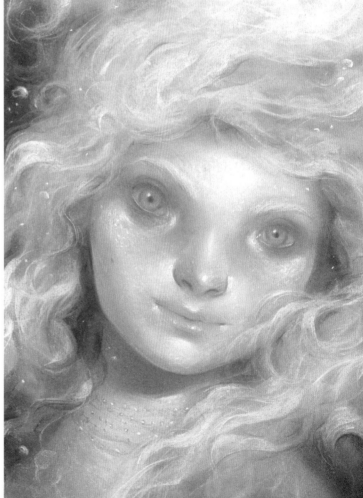

RAD!

An interview with Anand Radhakrishnan

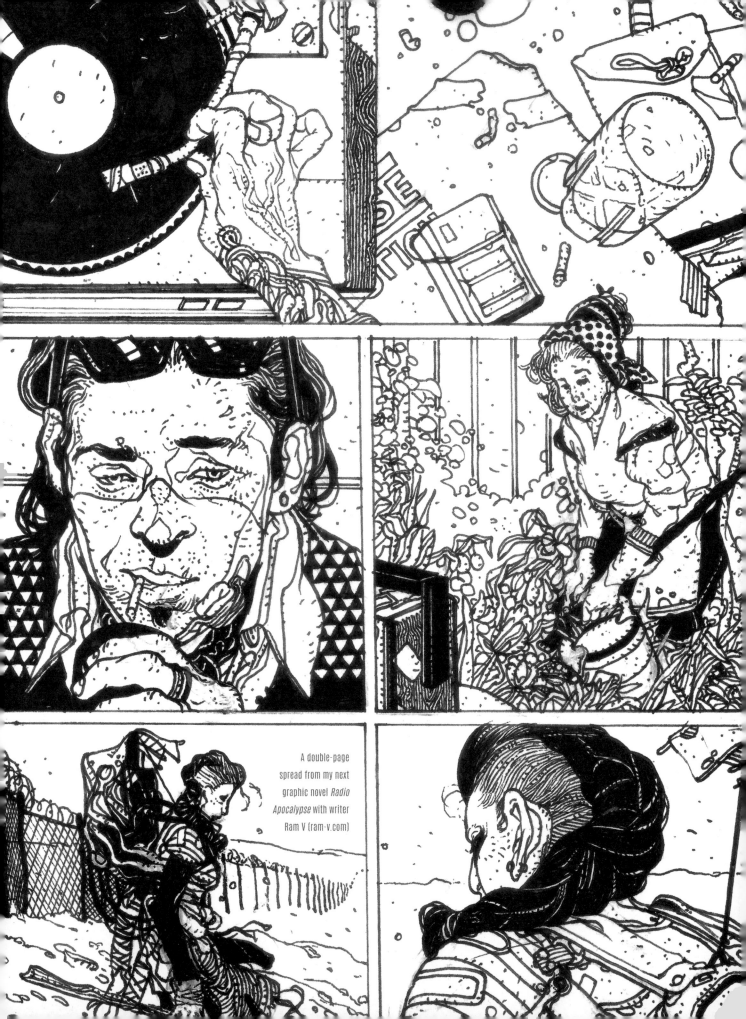

A double-page spread from my next graphic novel *Radio Apocalypse* with writer Ram V (ram-v.com)

Mumbai-based illustrator Anand Radhakrishnan creates vivid, characterful artwork with a wide range of techniques and a masterful grasp of the figure. We learn more about his background, inspirations, and creative methods in this interview.

Q· Thank you for speaking to GRAPHITE, Anand! Could you start off with a bit about your background and where you're based?

A· I live and work in Mumbai, the industrial and business capital of India. In 2011, I graduated with a BFA in illustration from Sir J. J. Institute of Applied Art here in Mumbai, after which I further studied drawing, painting, and illustration with the now-defunct online school The Art Department (TAD), which was run partly by The Illustration Academy. Since then I have been working freelance as an illustrator and quite recently as a comic book artist.

Q· What first inspired your interest in art? What inspires you today?

A· The ability to tell stories and to create worlds while sitting at your drawing table is what I find most amazing about drawing, and art in general. The idea of timelessness – a piece of art is potentially immortal and might even survive centuries after the artist's lifetime. That is quite powerful, I think.

Of course, what inspired me at the very beginning were simpler things, like being able to draw better than people around me. When you are a kid and you realize that you are actually good at something, you tend to gloat and do a lot of it!

Q· What was your experience of formal art education like? Are there any particular skills you've taken away from it?

A· In total I have spent six years studying various aspects of art and image-making. The first four years were applied art, more focused towards advertising, and the last two were pure study and illustration. I learned very different skills from both of those courses. Applied art taught me about problem-solving and using images to illustrate text. It also taught me versatility, which is very important in the advertising world.

At TAD I learned more academic skills: how to break down art, draw scientifically, and know what works aesthetically and why. The power of value, color, composition, perspective, anatomy, and so on. The sketchbook classes at TAD taught me how to relate ideas to images and problem-solve by using drawing as a tool.

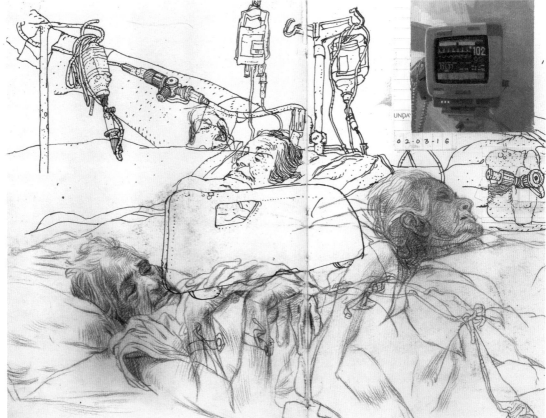

Left
The studio is where I tune out of everything else, put an audiobook on, and just draw

Right
Spreads from my observational sketchbook. This book is strictly for sketching what I see, almost like a visual diary, recording accounts of my travels and experiences

"I naturally gravitate towards narrative and sequential art"

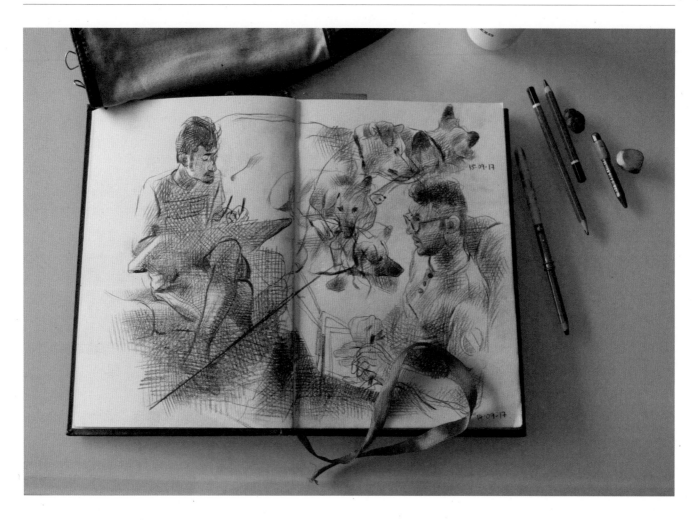

Q· What themes or subjects do you enjoy exploring in your work?

A· I have always loved telling stories, in any medium, so I naturally gravitate towards narrative and sequential art. I also enjoy inventing and exploring new worlds; I read quite a bit of science fiction and fantasy, so they have always been areas of deep interest. I am intrigued by the strange. This seems to be a recurring theme in my work currently. I like to evoke the feeling of being "creeped out" in the viewer, but without shocking them. If something is just a little bit "off" from reality, short of the absolutely ridiculous, that can be unsettling. This idea is very interesting to me.

Q· What is the comics scene like in Mumbai? How do you like to get involved?

A· I think this is a great time for comics in India. There are many artists, like myself, who grew up reading local and American comics, and are now creators and want to produce good work and tell some terrific stories. We have a rich history of both comics and children's books that teach children about mythology and historical characters. But that is where the problem lies. Comics and graphic novels are still considered a product for children and teens, so the mainstream stories are crafted with that in mind, though that attitude is changing slowly with more

independent creators and small publishers taking a stand.

I am still fairly new to comics. *Grafity's Wall*, a book I am working on with UK-based writer Ram V (ram-v.com and @therightram on Twitter), will be my first. So far this is my only contribution to the scene but hopefully there will be more in the near future.

Above: A spread from my observational sketchbook. I have two dogs and I love drawing them – they make the best models!

Right: A sketch of my wife watching her favorite YouTube channel while rolling a cigarette

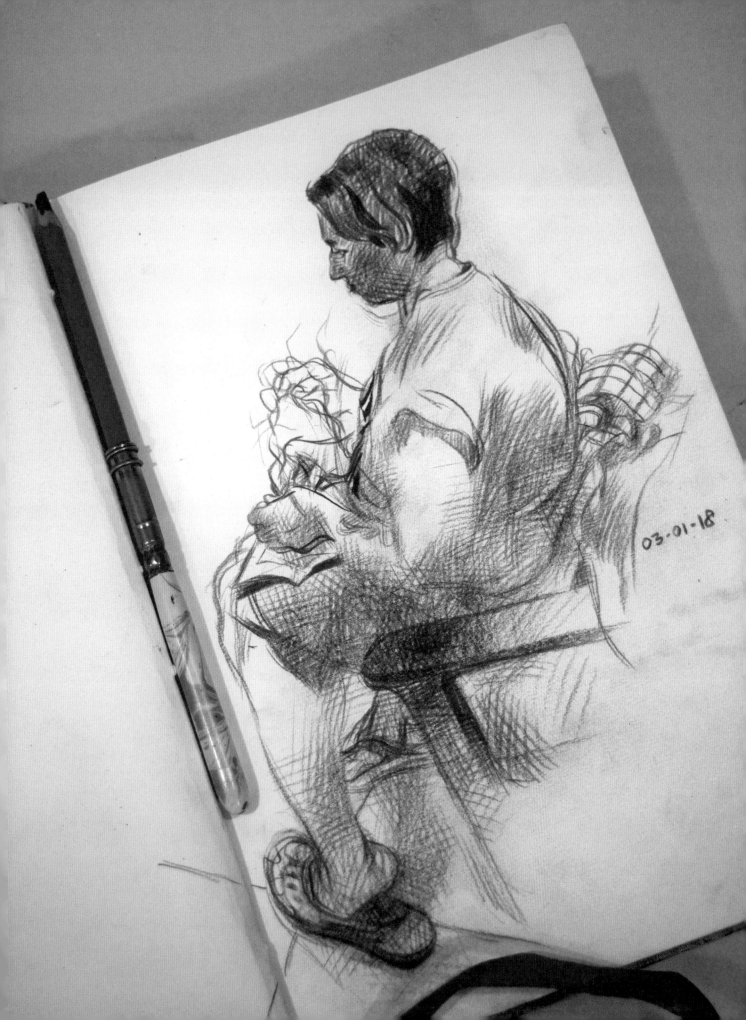

03·01·18

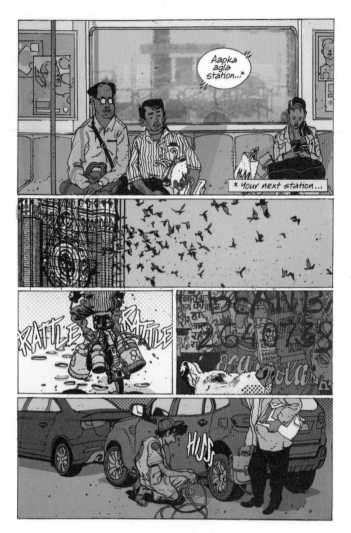

> "Ink is one of those mediums that looks good if used boldly and confidently, even if the perspective is off or the proportions look wrong. Be fearless of the medium and keep at it"

Q· Tell us about the tools and materials you prefer. You use many different mediums, but do you have any particular favorites?

A· Many of the assignments in college required the use of water-based media such as watercolor and poster paints. I was terrible with them but since it was so rigidly enforced, I had no alternative other than to practice and get better with them. Those techniques stuck with me even after college, when I started working professionally.

Dry media (pastels and charcoal) and oil paints are tools I picked up at TAD. After I began to understand the basics and rules, it became easier to apply them to any medium with a little practice. I have a long, long way to go, but I can confidently say that I am happy to fail at any medium, and keep working at it until I crack it.

I think my favorite medium would be ink because of how versatile it is. I think there is no effect or feeling you can't convey with ink. The permanence of ink also makes it feel intimidating and exciting.

Q· Do you have any advice for artists hoping to improve their skills with ink?

A· *Make mistakes.* Ink is one of those mediums that looks good if used boldly and confidently, even if the perspective is off or the proportions look wrong. Be fearless of the medium and keep at it.

These pages
A few pages from the graphic novel I am currently working on, *Grafity's Wall*, which is based on the urban culture and life of Mumbai. The project is a collaboration with writer Ram V (ram-v.com)

Q· What do you think is the most satisfying or rewarding thing about being an illustrator?

A· For me it's quite simply the fact that I get to draw for a living. To be able to tell a story and direct the lives of characters is quite fascinating. Creating characters who are relatable and have storylines and personalities is powerful to me.

I also work on numerous projects at once, both professional and personal, so there is no space for boredom or monotony. It's all extremely exciting and I know very few people who can say that about their work. I am very thankful for this.

Q· How do you keep organized and motivated as a freelance artist?

A· I don't! Seriously, organization is quite a task. I had trouble meeting deadlines when I used to work from my home studio, because there was no clear line between work and leisure. I would get neither enough work done nor enough rest! But lately I have started renting a small studio and I think that has increased my productivity. In my opinion, having a clear distinction between home and workspace is important to be able to play all of your roles efficiently. I also maintain a notebook where I list things that need to be done on any particular day. I am a big fan of using checklists.

I have never had trouble with motivation. I have enough projects running on the side that I can keep shuffling between, so none of them become dry and repetitive. I also have a rule

for myself: never take up uninteresting work just for money. This ensures that I am engaged in whatever work I take up professionally, and also that I give it my best.

Q· What do you like to do in your spare time?

A· I am a huge fan of audiobooks, so much so that now I can't work without listening to them. I love reading and watching films too, whenever I find the time to. I am also a bit of a fitness nut, so I like to work out. Apart from that, I love spending time with my family and my two dogs.

These pages: Spreads from my sketchbook series *Weird India* where I explore the weird and the strange with some historical reference points

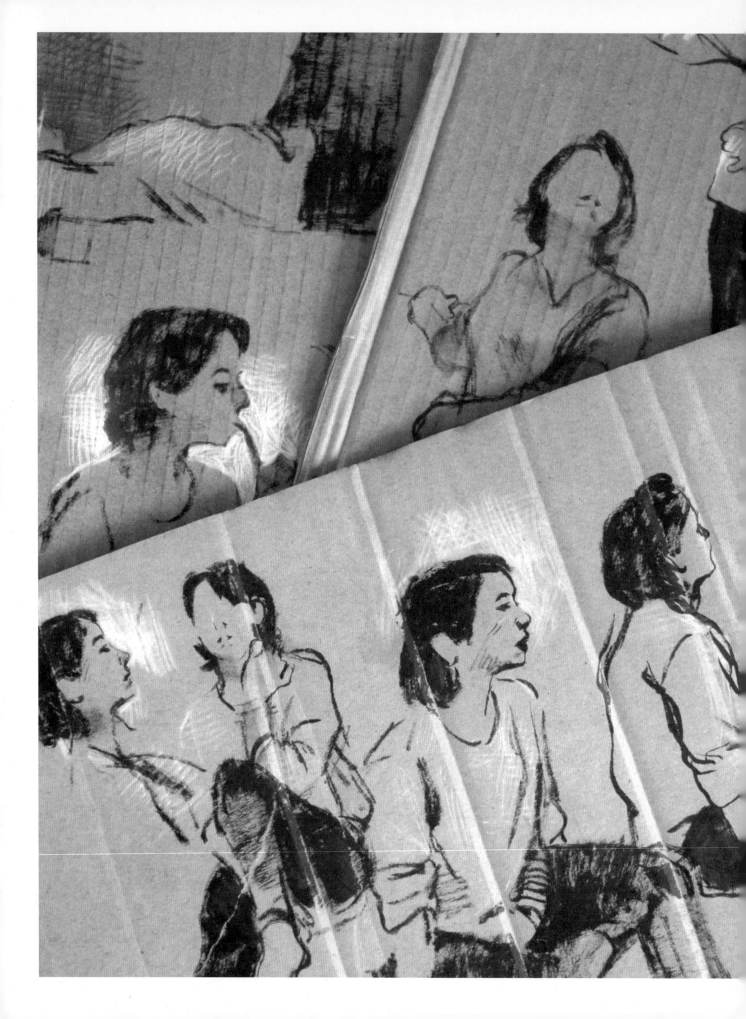

SOCiAL SKETCHING

Life drawing methods with Anand Radhakrishnan

Illustrator Anand Radhakrishnan shares some insights into drawing and observational sketching in different contexts.

Far left
I start by drawing whatever I find interesting: in this case, the head of a dear friend from my life drawing group

Near left
It is inevitable that the person you draw is going to move, so don't fret, and keep drawing. Leave the incomplete drawing, and if your subject returns to that pose, you can go back and finish it

Near right
I always find profiles very interesting to draw. Here is another example of when the person moved and I just kept drawing — often drawing over the previous poses. Don't worry about making the page pretty!

Far right
The overlapping of previous poses and sketches gives the drawings a feeling of movement that I like. It makes them feel animated and not stiff

I am an illustrator working out of the city of Mumbai in India, and have been working freelance full-time since 2014. Previously, I studied art and illustration for about six years. I have created work across a wide variety of genres, from comics to magazine editorials, and book covers.

Besides illustration commissions, my sketchbooks and personal projects occupy a substantial part of my body of work. I have maintained sketchbooks for a very long time now, perhaps even since I first started drawing. I think a sketchbook is much more than just a drawing book; it's a window into what the artist is truly capable of, to projects that are not yet produced and out in the world. A sketchbook is a compilation of failings, thoughts, ideas, and experiences that I think are essential to the growth of an artist.

At any given time, I usually have two or three sketchbooks that I am working on, depending on the subject matter or project. In this article, I will cover a selection of drawings and pages from some of my ongoing sketchbooks, and take you through the techniques and philosophy behind them.

Sketching people

One of my favorite things to do when I go out with friends, especially if they are also working artists, is to draw. Usually, it would be odd to whip your sketchbook out and start drawing in the middle of a social gathering, but within a group of artists it is totally acceptable and even encouraged.

Locations such as restaurants are some of the best places to draw people without them being self-conscious and giving you a stiff pose. In places such as these, people are generally at ease and relaxed, and you get to

"I carry my observational sketchbook and roll of pencils everywhere I go"

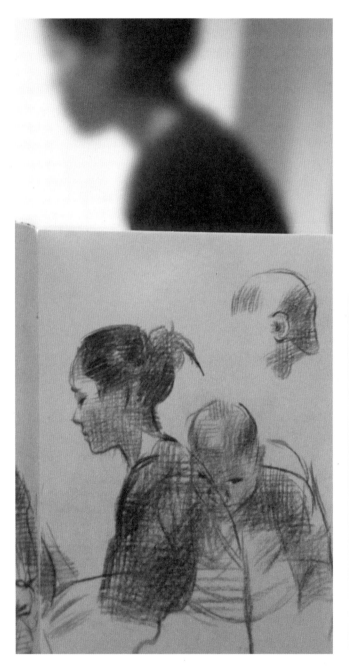

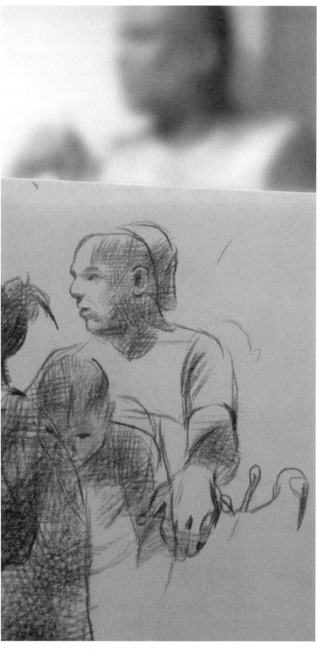

draw people from various walks of life with different body types – something you do not generally get to do at life drawing events.

I carry my observational sketchbook and roll of pencils everywhere I go, so it's full of people waiting in restaurants, at bus stops and train stations, and so on. It's a hodge-podge of poses, objects, urban sketches, and notes – anything I might have found interesting at the time. I think of this book as a visual diary, capturing moments in time in a spread of my sketchbook. I like to compose sketches to form a "spread" which could be referred to as a larger piece, as you can see overleaf. I have more regard for the larger image than the individual sketches in the spread that form the whole.

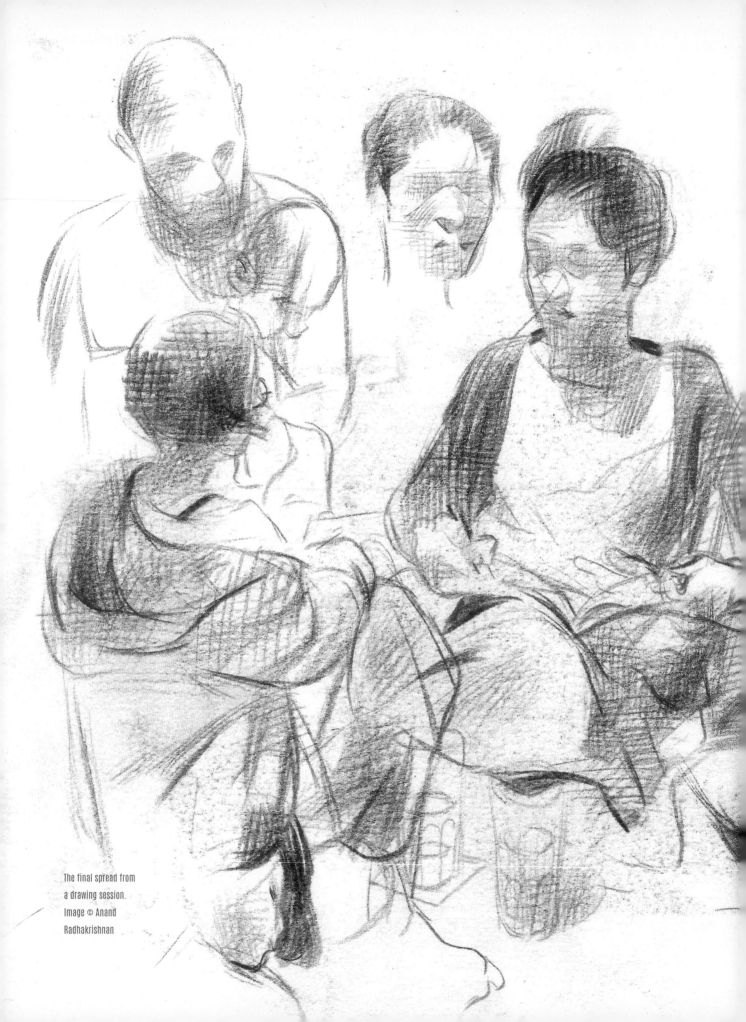

The final spread from
a drawing session.
Image © Anand
Radhakrishnan

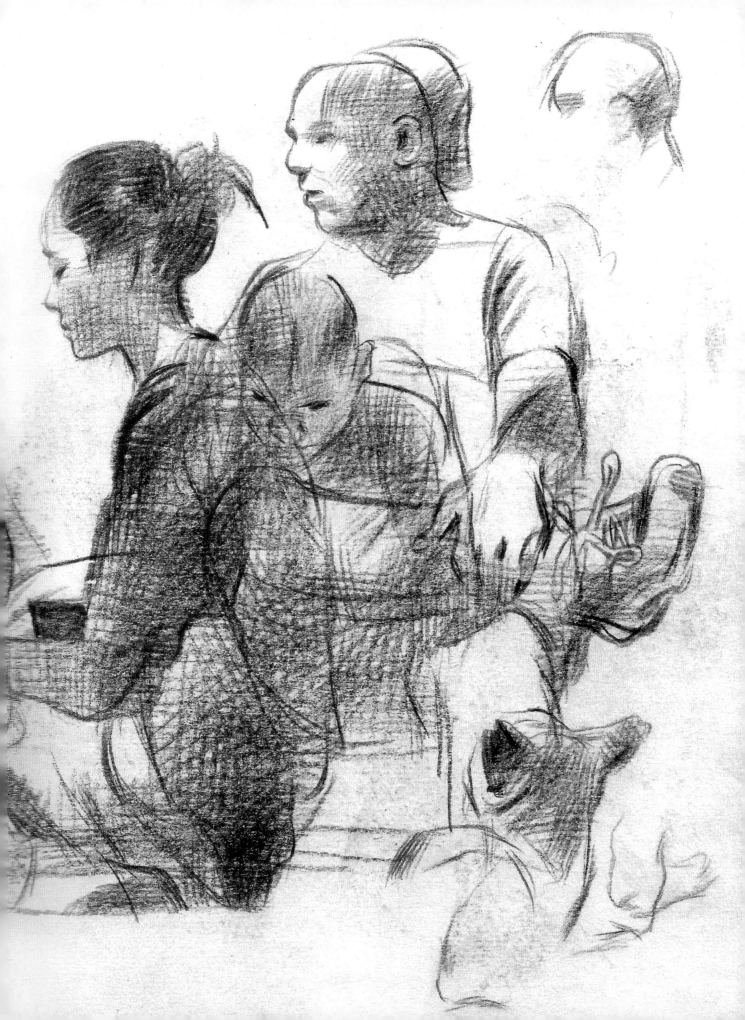

Life drawing (short poses)

For the last year and a half or so, several of my artist friends and I have met every Saturday to conduct life drawing sessions here in Mumbai. These sessions are divided into two parts. The first couple of hours consist of shorter poses where the model gives us 10 –15 minute poses that they can hold comfortably, and the second part of the session is a longer stationary pose that is more focused on a portrait or bust. On these pages, you can see the results of the shorter poses from a session.

I think drawing from life is essential for an artist, especially to feed your visual vocabulary – the bank that you draw from while sketching from the imagination. I also treat these sessions as an opportunity to explore and experiment with media. Here I am using a brush pen on packing cardboard. The brown of the cardboard helps to offset the white highlights. These sessions are opportunities to make mistakes and learn; the idea is not to make pretty drawings, but to fail and learn from the mistakes.

Near right
The brush pen can help create interesting value variations, from solid blacks to subtle grays made when the brush is slightly dry

Middle top right
Start from any position of the body and go from there, judging the proportions to chart out the orientation of the figure. Drawing from life can pose some interesting foreshortening challenges

Far top right
I use white to address the highlights and add depth, which works especially well on this brown cardboard

Far bottom right
The sketches resulting from this life drawing session. Final image © Anand Radhakrishnan

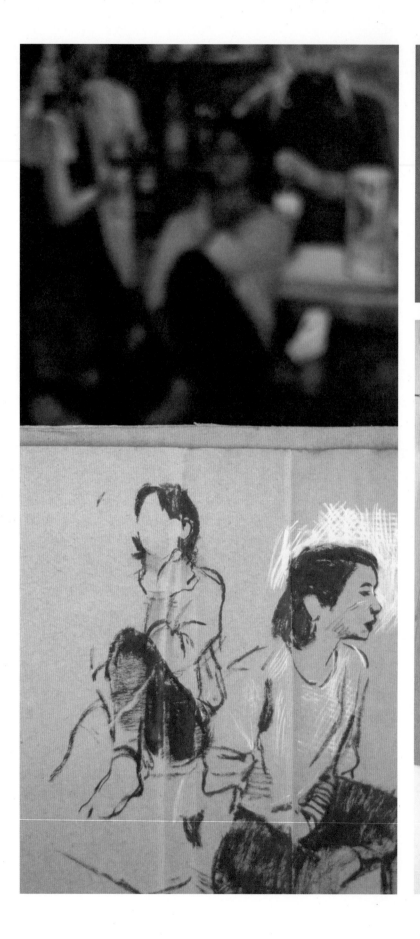

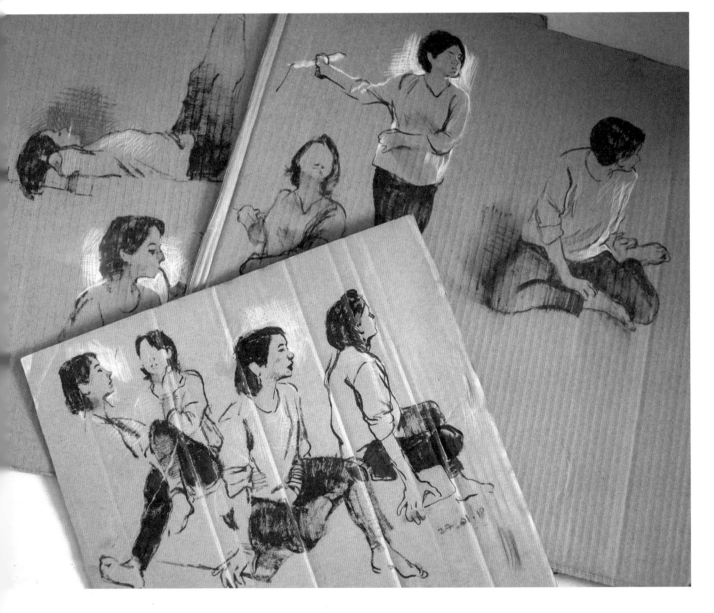

Life drawing (long poses)

Longer life drawing sessions allow you to create more involved and complex drawings. To be able to walk around and draw a figure in three dimensions – understanding how drapery folds around the figure and changes as the body moves, how the fingers curl when stationary, or how the head tilts when resting – is essential to be able to convey these subtleties in your drawings.

ARTIST'S TIPS

Masking

I was not a big fan of masking off borders or using masking fluid for highlights until recently. Now I think masking is very useful, especially while painting brightly lit areas in watercolor. I have a tendency to not leave any white on the paper when I need to, so it is especially useful for me. I have also found that electrical tape makes for good masking tape.

Being approached in public

It's almost unavoidable that you will be confronted or approached while drawing in public spaces such as bus stops and restaurants. It is ideal to be honest and humble, yet respectful of your art. Don't stare at people; if they have noticed and are offended, show them the drawing and talk to them about what you do. In most cases they will understand, and even be flattered. Perhaps they might even want to take a picture of it with you!

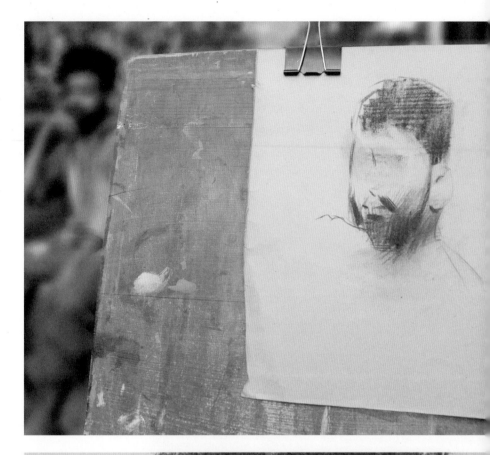

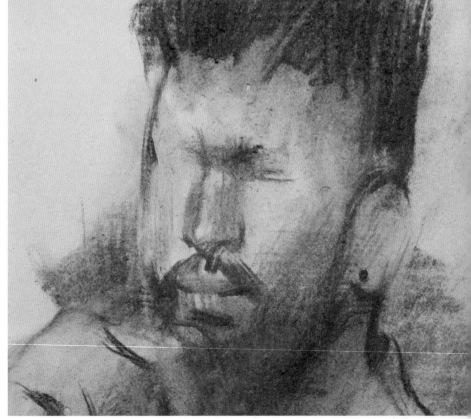

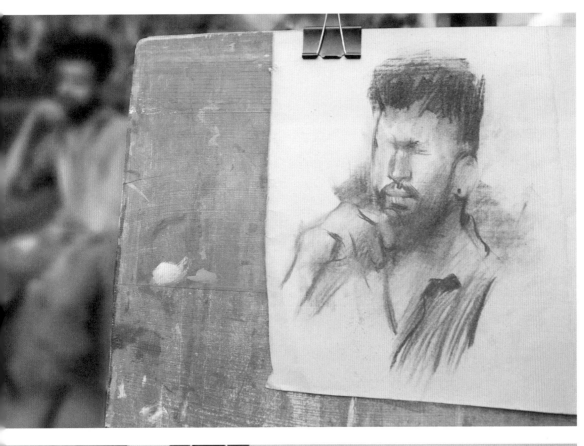

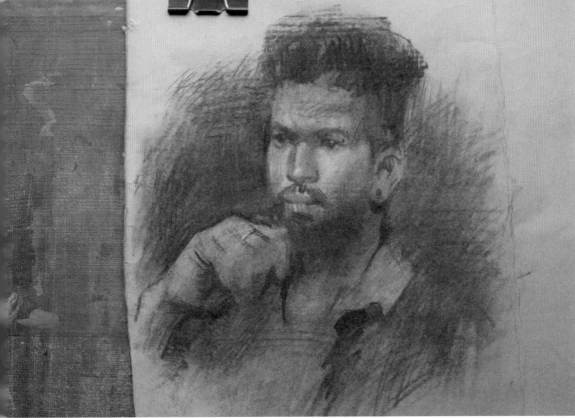

Far top left
In this particular instance we were drawing outdoors in the evening, so there was no single strong light source. Instead I used "occlusion" shadows to suggest dimension

Near top left
Vine charcoal is a lot of fun and a very delicate medium. It's not exactly suited for someone as heavy-handed as me, but still exciting to use!

Far bottom left
I use hatching as a way to add dimension with the charcoal. This pose was less than 40 minutes long, so this "strokey" hatching technique suited the situation best

Near bottom left
I sometimes use paper stubs to draw while using vine charcoal, as they help to soften the edges and create a lighter gray in areas where I don't want a very dark tone. The last stage of the drawing involves blending, refining, and adding the highlights. Final image © Anand Radhakrishnan

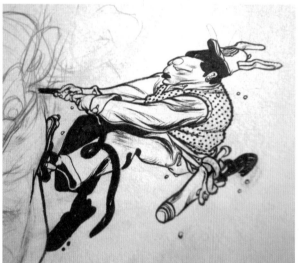

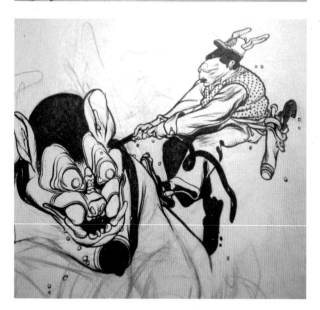

Drawing from imagination

This final section does not involve drawing from observation, but from imagination. If you are an illustrator, you probably draw heavily from your imagination, using references to guide you along the way or relying entirely on your memory to "invent." Either way, it is an excellent exercise to practice, because the mental processes we use for observational drawing are not the same as those we use for drawing completely from imagination. This is the reason why most artists draw very differently when they are asked to draw something using only memory as a reference point. Of course, every time we draw from life or from a reference image, we feed our visual vocabulary, and the more we study the more we can draw from that bank.

While drawing from the imagination, it is easy to forget or miss subtleties such as the force, weight, and mass of the subject, considerations which are essential when drawing from life. Adjusting the character's posture, adding folds of skin, or adding a secondary character can be useful ways to reinforce these elements. Working over a pencil sketch also allows you to plan the figures more thoroughly before committing with ink.

Top left
I start with a very rough drawing, laying out shapes and relations between multiple figures. I then begin to ink directly over this using a black Kuretake brush pen

Middle left
This drawing technique is much more stylized and simplified than my other work, but it's indicative of the direction I want to take my commissioned work to. You can also see where I have used white Liquitex acrylic for corrections.

Bottom left
I have been reading about and researching my culture, so a lot of it permeates my work. For the creature character, I referred to ancient South Indian and Sri Lankan lion temple statues and carvings

Right
The final drawing includes some ink spattering to create a gritty texture.
Image © Anand Radhakrishnan

For more drawing advice by Anand, visit the graphitemag.com website.

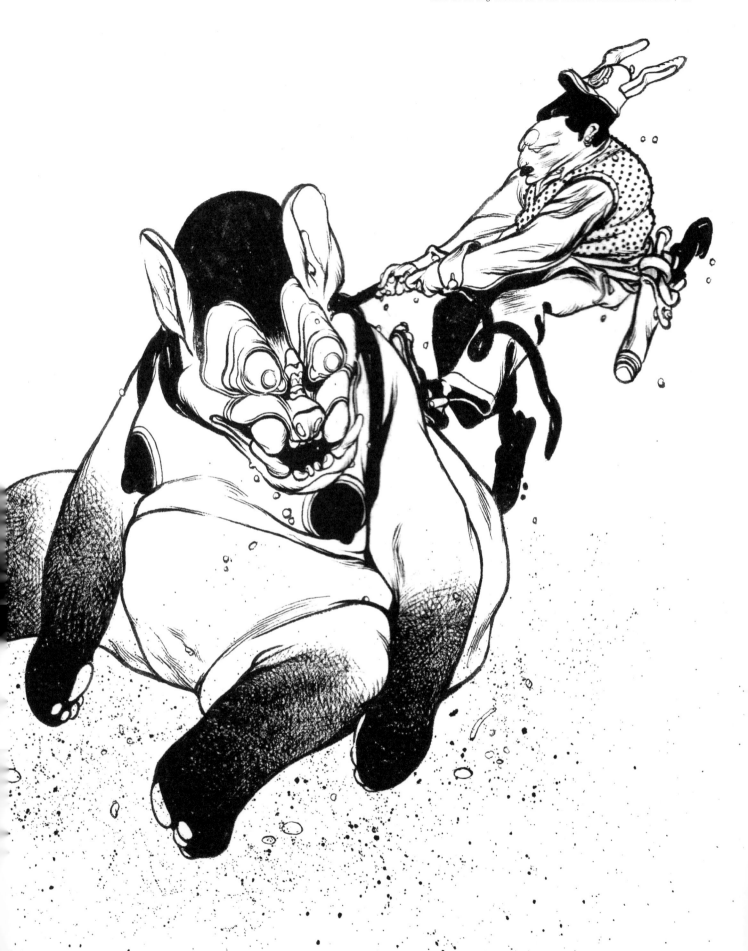

HUNTED

A narrative illustration project with Amber Ma | Story by Adam J. Smith

"Across the snow she followed the distinctive footprints of the creature. They trailed into the treeline, and with each crunching step, and with her breath billowing and her knuckles tensed to white, the further she pulled on the bowstring. The footprints disappeared into the woods; two large steps and then nothing. She cocked her head, listening. Snow, sifted by the tree, fell with a whisper around her. She looked up. The creature had been waiting."

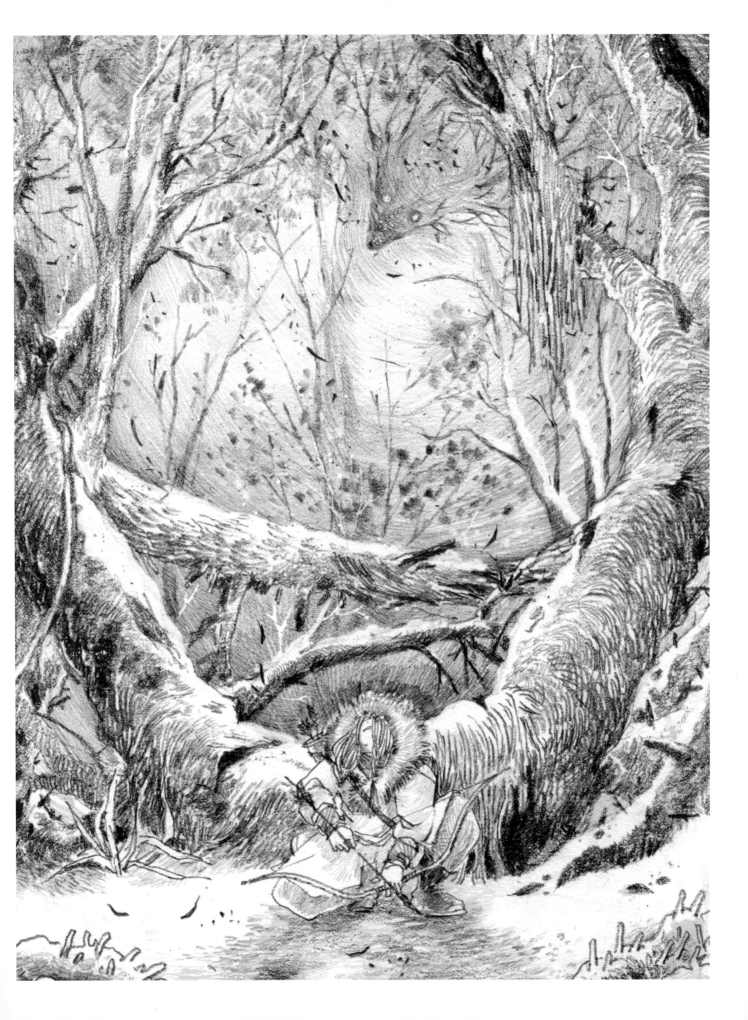

Join illustrator and visual storyteller Amber Ma in creating an atmospheric winter scene that uses graphite to achieve different textured effects.

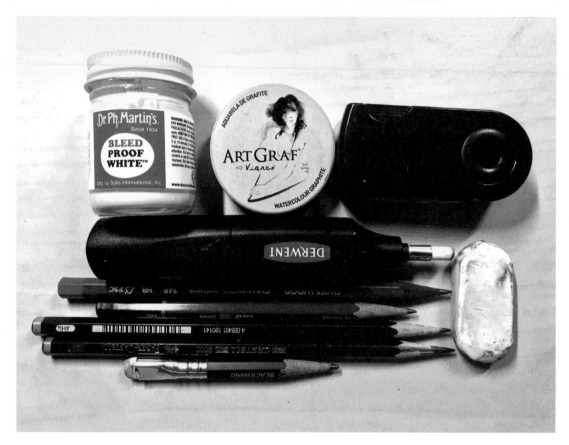

Left
The tools used for this project

Top right
Three potential thumbnails

Bottom near right
A larger rough sketch based on the first thumbnail

Bottom far right
Tracing the rough sketch on a lightbox

I am a New York-based artist and illustrator, originally from China, and have always been attracted to art and storytelling. My passion for drawing led me to pursue an MFA in Illustration as Visual Essay at the School of Visual Arts, New York. I believe that everything, every moment, every element, has the potential to be a good story.

Illustrating an article or a short story is always a lot of fun for me. Words are effective for communicating abstract concepts, and conveying the plot and structure of a story, giving people space to use their imaginations. Meanwhile, an illustration brings a kind of mystery and visual atmosphere that can greatly expand a written idea. When I read this text, several images come to mind, but before drawing on paper I need to decide which part I want to illustrate. I eventually choose the last sentence to draw, because it has a very strong atmosphere.

Tools
For this project I will use a range of pencils (HB, 2H, 4H, 6B), water-soluble graphite by Art Graf (called Watercolor Graphite on the tin), and Dr. Ph. Martin's Bleedproof White ink. It is useful to have one large eraser and one fine eraser (mine is a battery-operated one by Derwent). I will also use a cheap toothbrush to add finishing touches to the image.

Thumbnails
I always start by drawing as many rough sketches as I can, to see which options have the most space to develop. As I mentioned before, I chose the last sentence of the text to illustrate, so I draw different angles and interpretations of the scene to see which one is the most powerful and interesting. I narrow my ideas down to three main thumbnails.

Rough sketch
I choose to develop the first thumbnail. The tall composition will allow plenty of room to build up the atmospheric forest environment, and to hide the monster in the background behind the character. I use a new sheet of paper to draw a clearer, larger sketch, marking out the darkest parts of the forest.

Lightbox
To transfer the rough sketch to a sheet of good quality drawing paper, I place the new paper over the sketch and secure both sheets to my lightbox with masking tape. I trace the lines with a soft 6B pencil, shading in some of the darkest parts of the trees and shadows, and leaving white space for the snow.

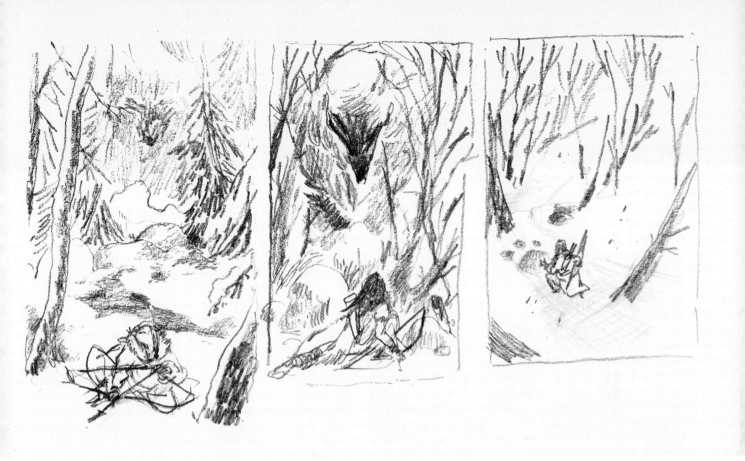
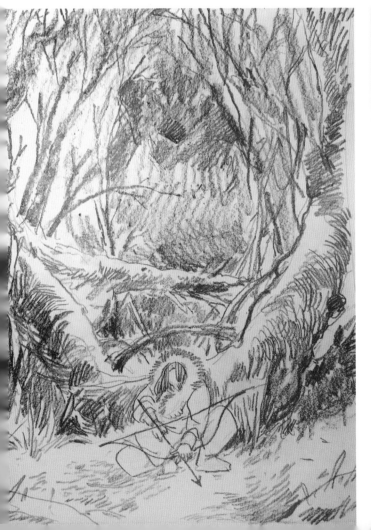
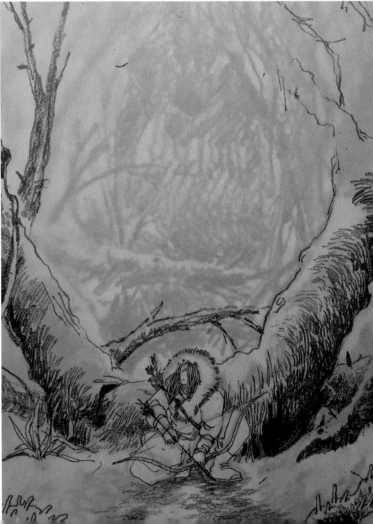

"I don't normally trace the background because it makes the image too dense"

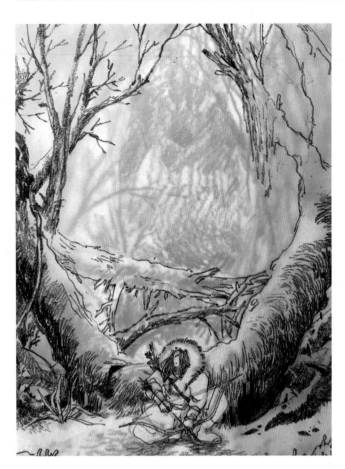

Traced drawing

Here you can see the results of the transfer process. I have drawn the trees, fallen branches, and character in the foreground, but have not traced the background. I don't normally trace the background because it makes the image too dense and rich at this early stage. Instead, I will add the background from scratch without using the lightbox.

Starting the background

I remove the drawing from the lightbox and continue to work on it. I use a 4H pencil to begin shading in the background. This takes a while to do because the 4H pencil is much harder than the 6B pencil used previously, so its effects are much more fine and subtle, but it will help to build up an intense atmosphere.

Adding more depth

I switch to an HB pencil to add a darker second layer of shading to the background. I also use this pencil to darken the corners of the scene, and to add more depth and shading to the trees and foliage in the foreground.

The mystery monster

The creature mentioned in the text is hiding above the character, concealed by the trees. I want the drawing to show a monster that spends all its time hiding deep in the forest.

Its body should be almost invisible, to suggest that it's a mysterious, unknown creature. To achieve this effect, I make the lines of the monster's body follow and fade into the texture of the background.

Above
The traced drawing, with and without the sketch underneath

Top near right
Building up the background with a 4H pencil

Top far right & bottom near right
Adding depth to the shadows

Bottom far right
Sketching in the shape of the monster

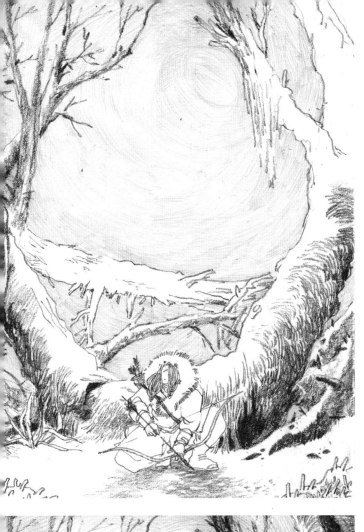
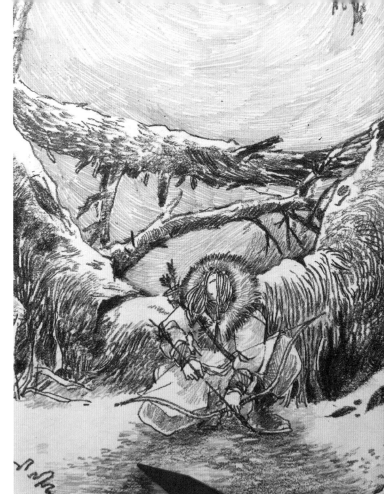
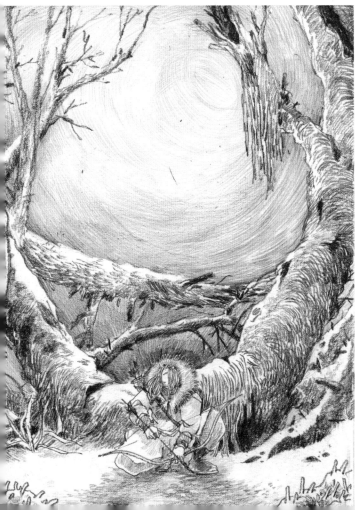
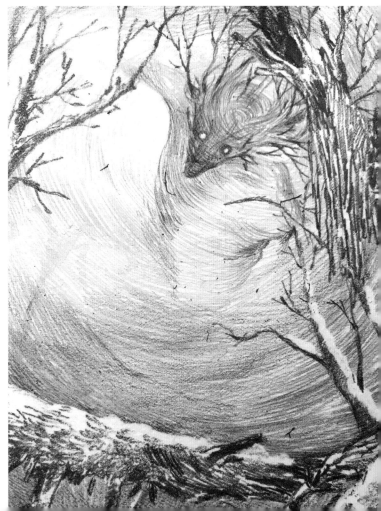

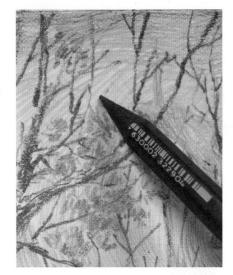

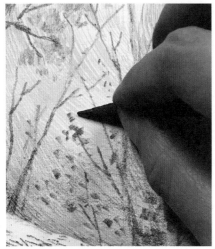

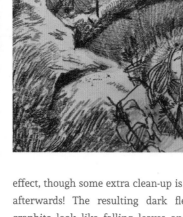

Adding leaves

I bring the forest to life by adding leaves to the branches, using two different techniques to render them. The first technique is to draw them using light, scribbled strokes, and the second technique is to create marks with the side of the pencil. The latter is my favorite method because the results look more spontaneous and natural.

Applying water-soluble graphite

I want to add some texture using water-soluble graphite: in this case, Art Graf Watercolour Graphite. I use a cheap, wet toothbrush to pick up a little of the graphite, then grip the toothbrush close to the head and drag my thumbnail back across the bristles. This creates a unique, unpredictable effect, though some extra clean-up is needed afterwards! The resulting dark flecks of graphite look like falling leaves and twigs disturbed by the wind or the creature.

White highlights

Now I use a pencil to pick up some of Dr. Ph. Martin's Bleedproof White ink, and draw highlights on the trees and leaves in the background. I also clean the toothbrush and use it to spray a few areas of white speckles onto the image, like falling snow.

The final image

The illustration is now complete. The white highlights on the trees and ground suggest the snow mentioned in the story. The textures created with the toothbrush give an almost audible sense of the weather and forest. The hunter in the foreground is stealthy, alert, and camouflaged, but even she is unaware of the creature hidden in the leaves behind her.

Above left
Adding leaves to the trees

Above right & top right
Applying Art Graf
Watercolour Graphite

Bottom near right
Applying white
ink highlights

Bottom far right
Final image © Amber Ma

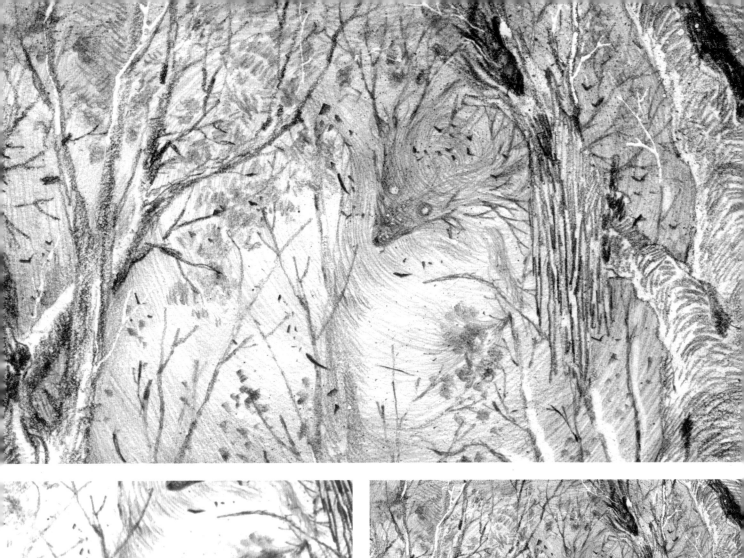

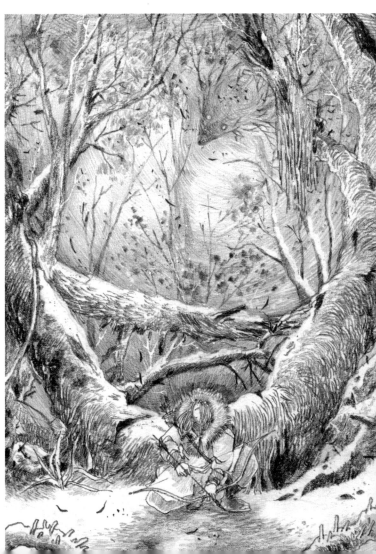

THE
GALLERY

Featured artists:

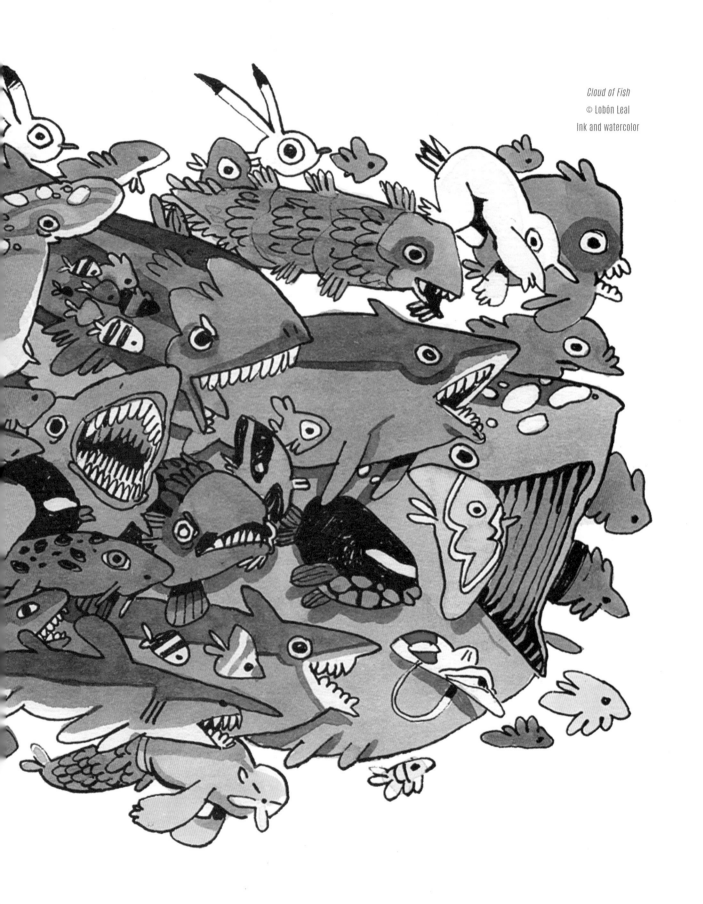

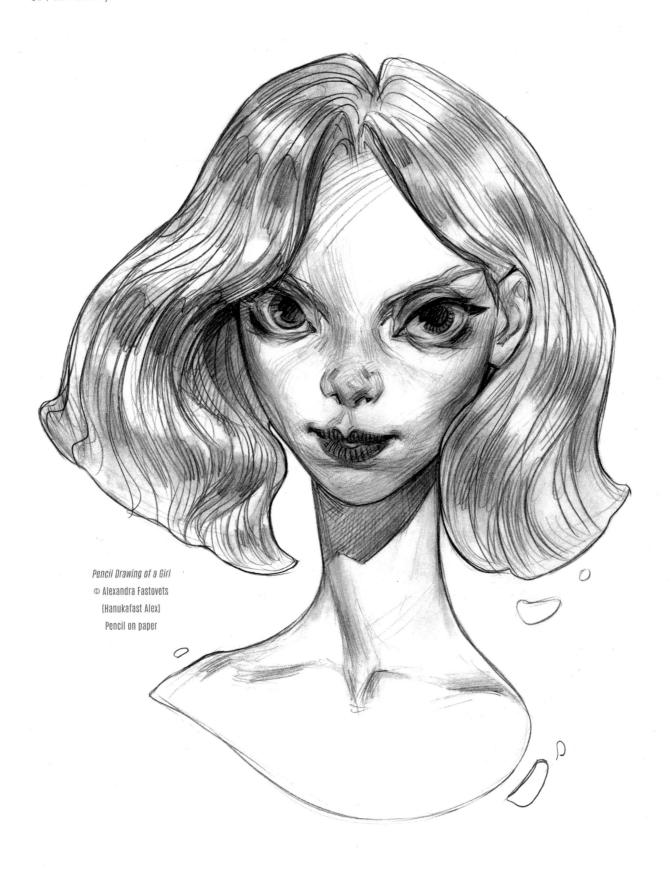

Pencil Drawing of a Girl
© Alexandra Fastovets
(Hanukafast Alex)
Pencil on paper

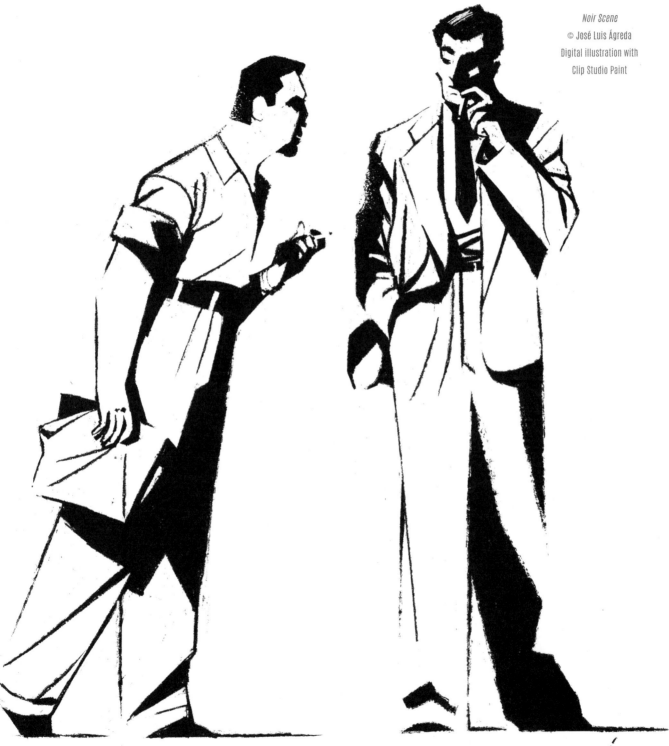

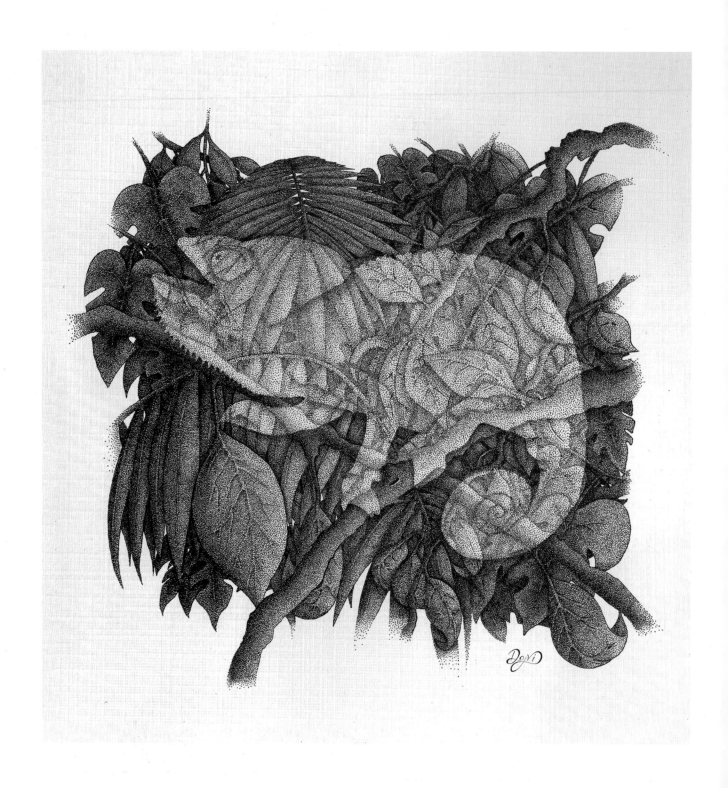

The Chameleon © Dejvid Knežević • Rotring Isograph 0.13 mm pen

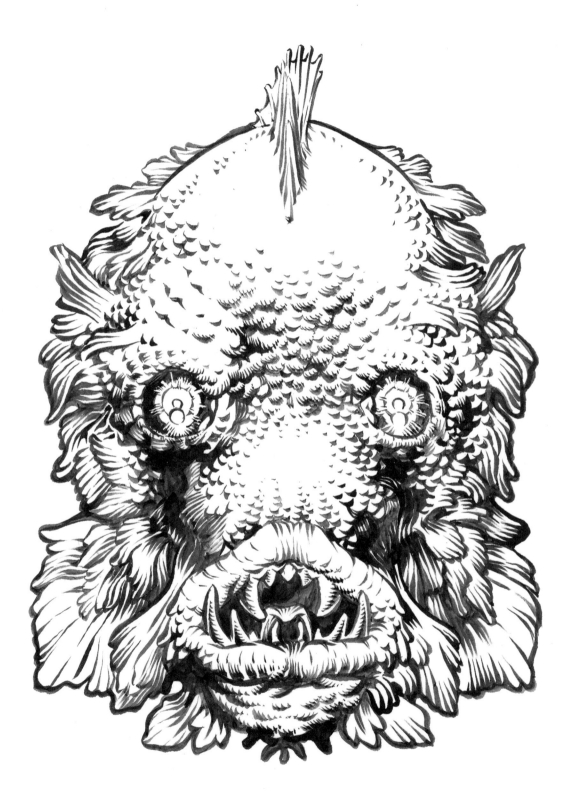

Inktober Mask © Conor Nolan • India ink on Bristol paper

Owl Tree © Ralukko (Raluca Fratean) • Black ballpoint pen on a Japanese album Moleskine

Winterqueen © Margaux Kindhauser • Blue Prismacolor pencil and Stabilo gold pen

THE GALLERY CONTRIBUTORS

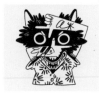 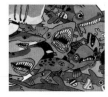

Francisco Lobón Leal is a concept artist, illustrator, and instructor at Escuela Superior de Dibujo Profesional (ESDIP) in Madrid. He develops his professional projects by participating in comic contests and fairs.

instagram.com/lobonleal

Alexandra Fastovets (Hanukafast Alex) is a freelance artist from Ukraine. She mostly creates digital art, but also loves traditional art and plans to return to oil painting soon.

instagram.com/hanukafast

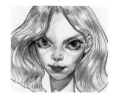

José Luis Ágreda is an illustrator for magazines (*Cosmopolitan*, *El Pais*) and major Spanish book publishers. He is also a character designer (Disney TV, Neptuno Films) and art director for the animated feature film *Buñuel in the Labyrinth of the Turtles*.

joseluisagreda.com

Dejvid Knežević is a freelance stippling illustrator from Slovenia. His illustrations contain anywhere between 10,000 to 150,000 dots, with motifs inspired by psychology, philosophy, and sociology. *The Chameleon* contains approximately 35,000 dots and took 47 hours to complete.

dejvid.net

Conor Nolan has worked with a variety of clients on a battery of platforms. Much of Conor's 2018 work will be in comic form. He lives in Rhode Island with his dog, where they break up time at the drawing desk with hiking and well-deserved coffee breaks.

conornolan.com

Raluca Fratean (aka Ralukko) is an illustrator, tea addict, owl lover, and faerie seeker who has been freelancing for almost seven years. When she is not busy with client work, Raluca chases her own stories and fills in sketchbooks with all sorts of mischievous creatures.

artstation.com/ralukko

Margaux Kindhauser is a comic book author and illustrator from Lausanne, Switzerland. She has published five comics and is now working on her new series, *Spirite* (Bamboo Publishing, France). In her free time, she bird-watches, plays ukulele, sings, reads, and stargazes.

instagram.com/margauxmara

AMPHIBIAN
DRAGON

Creature design in graphite with Ulksy

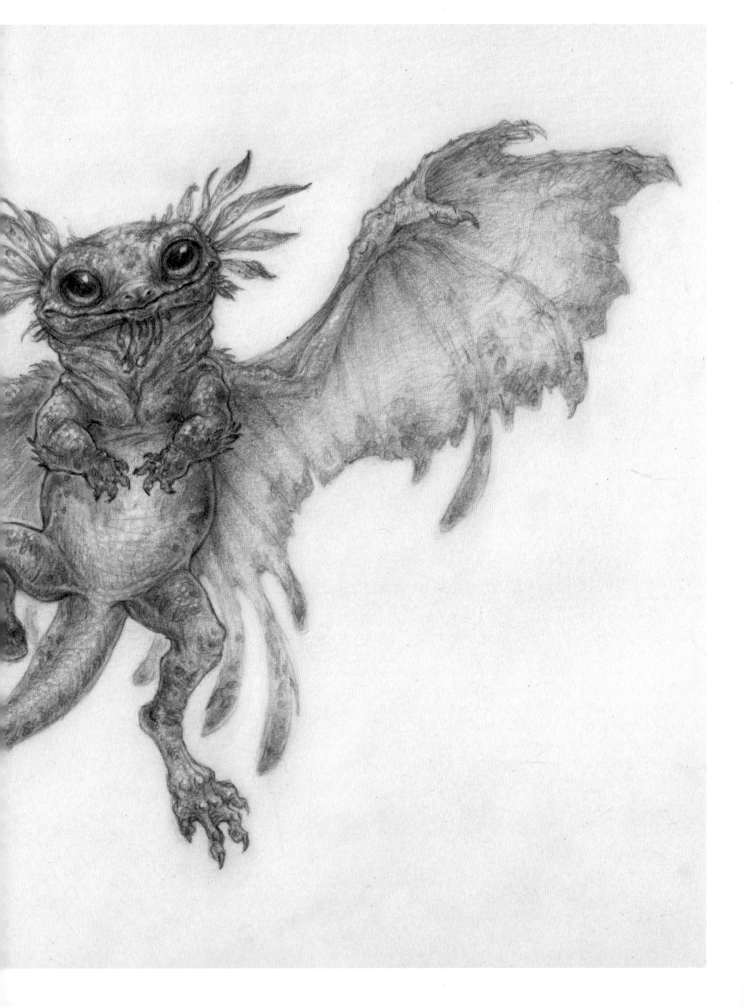

Join illustrator, concept artist, and dragon enthusiast Ulksy as she designs an amphibian-inspired dragon using graphite and erasers.

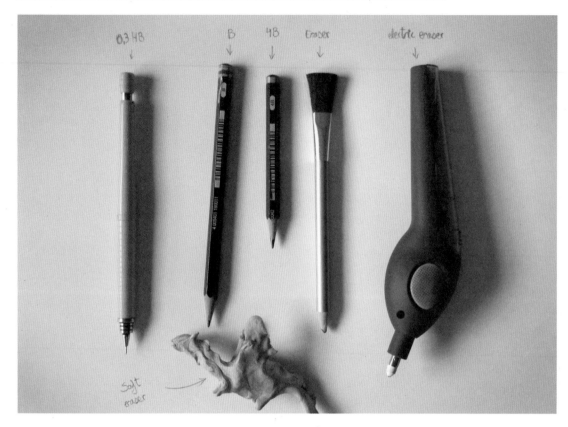

Left
The materials used
for this project

Top right
Sketches of some
different amphibians
such as an axolotl, a frog,
salamanders, and a tadpole

Bottom right
These first warm-up
doodles can generate some
interesting concepts

There are countless types of dragons – but have you ever heard of the amphibian dragon? In this tutorial I will show you the step-by-step process for drawing one of these curious creatures using graphite. It is important to begin with a defined idea; in this case, I am thinking of a small, chubby species with a somewhat toad-like appearance. It might have smooth, compact scales whose pattern mimics the speckled bark of the trees native to its marshy habitat.

Drawing tools

The materials I will use for this drawing are: HB and 4B wooden pencils, an 0.3 mm mechanical pencil, a putty eraser, a "pencil" eraser that I can sharpen, and a mechanical eraser. These are all pictured above.

The HB pencil will be for the initial sketch and the first shadows, the 4B pencil for the darker areas, and the 0.3 mm mechanical pencil for the small details.

I will use the malleable putty eraser to remove the first soft sketch lines, as it doesn't generate dirt and rubbings. I will also use it to create subtle blurring effects on the final drawing by gently pressing it to the areas farthest from the focal point.

The pencil eraser will be used for general highlighting, and cleaning the contours of the drawing if any parts become smudged. The electric eraser will be used for the final highlights, such as adding shine to the dragon's scales and eyes.

Research sketches

It is important to first do some research and look for references. The amount of diverse and strange amphibian species that exists is amazing, and will be great inspiration for the development of this creature.

There are amphibians with warts, spines, or smooth skins; rounded or elongated bodies; irregular, round, or horizontal pupils; and infinite different skin patterns! The more you understand the physiology and anatomy of your references, the more credibility your creatures will have.

Warming up

To begin a new project, I always make a series of quick sketches with a pen to generate some possible ideas that can lead to the next step. I take a pen or pencil and scribble without thinking too much. This part is fun, and you shouldn't be afraid of the doodles that come out of this; you will always end up with something interesting that you'll be able to use later.

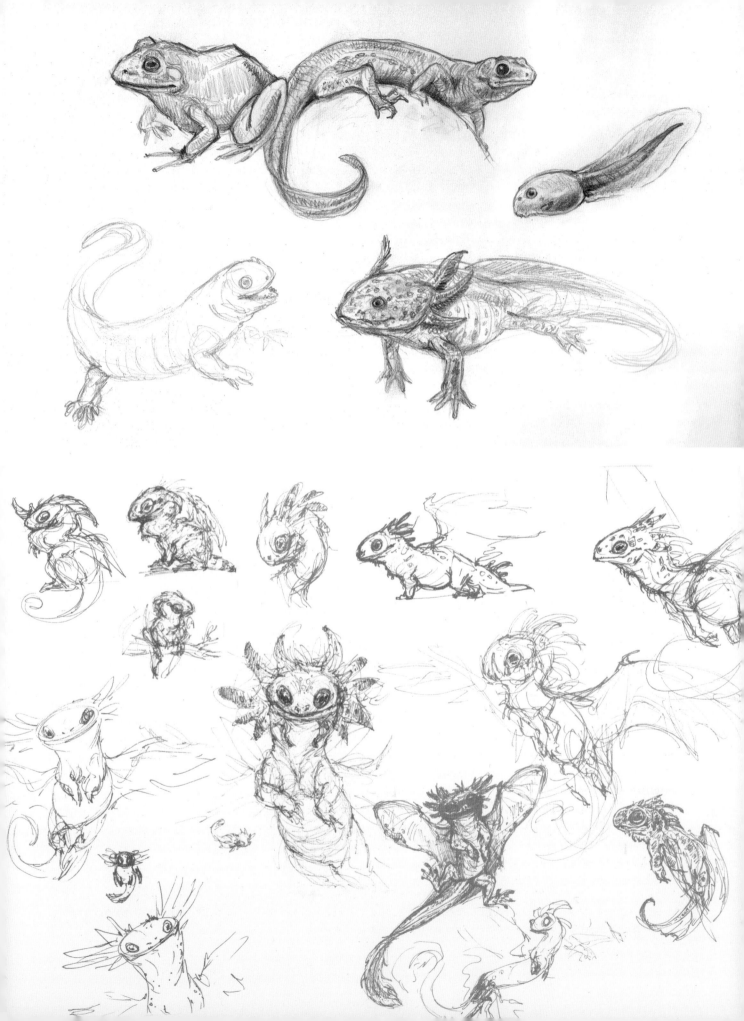

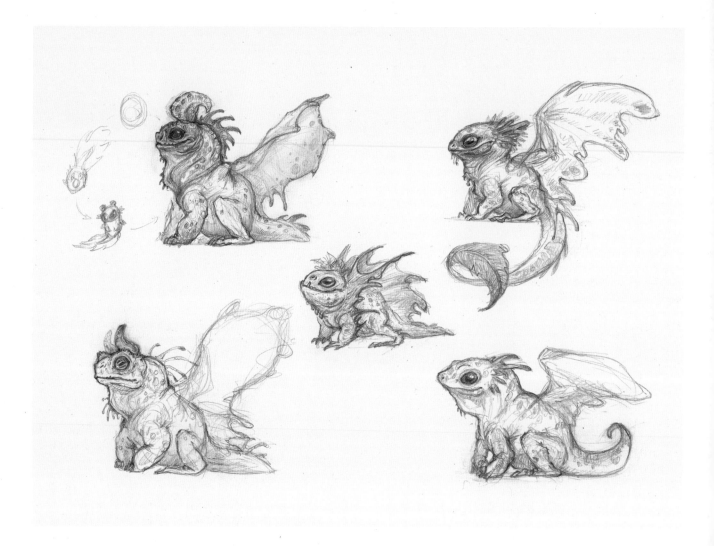

Exploratory doodles

I want this dragon to look like an amphibian, so after warming up with the previous doodles, I begin to explore designs that remind me more of a frog or toad. The two sketches on the left give the appearance of a dragon's size, being more large and corpulent, while the rest appear to be a smaller species. These smaller concepts, such as the one on the upper right, are better suited to my idea.

Choosing a concept

I start to focus on a salamander-like shape that is more slender and agile. These more elegant dragons seem like they could live in a more tropical and exotic place, rather than swampy environments like the previous sketches. I will keep those previous ideas for future drawings instead.

In the sketches on the top right, you can see the different larval phases of the dragon until it becomes an adult, inspired by my research into amphibians.

Developing the design

I decide to combine the salamander-like features with aspects of the smallest and chubbiest dragon on the top right of the "Exploratory doodles" page. This plump little species has a kind face that makes the design appealing and suggests its benevolent nature.

In the sketches shown on the right, I explore different poses and small variations on the design, along with fleshing out my ideas for the creature's life and environment. Thinking about these aspects will help to make a more unique design.

For example, I imagine the dragons live in floating trees, feeding on insects that approach them, attracted by the trees' bioluminescent fruit. Hence the dragons have small protuberances on their chins, ending in small spheres that mimic those fruits.

Above
A series of amphibian dragon sketches exploring initial ideas

Top right
A series of sketches exploring a different type of body, more stylized and similar to a salamander

Bottom right
Researching poses for the final selected species and drawing some studies of the trees native to their habitat

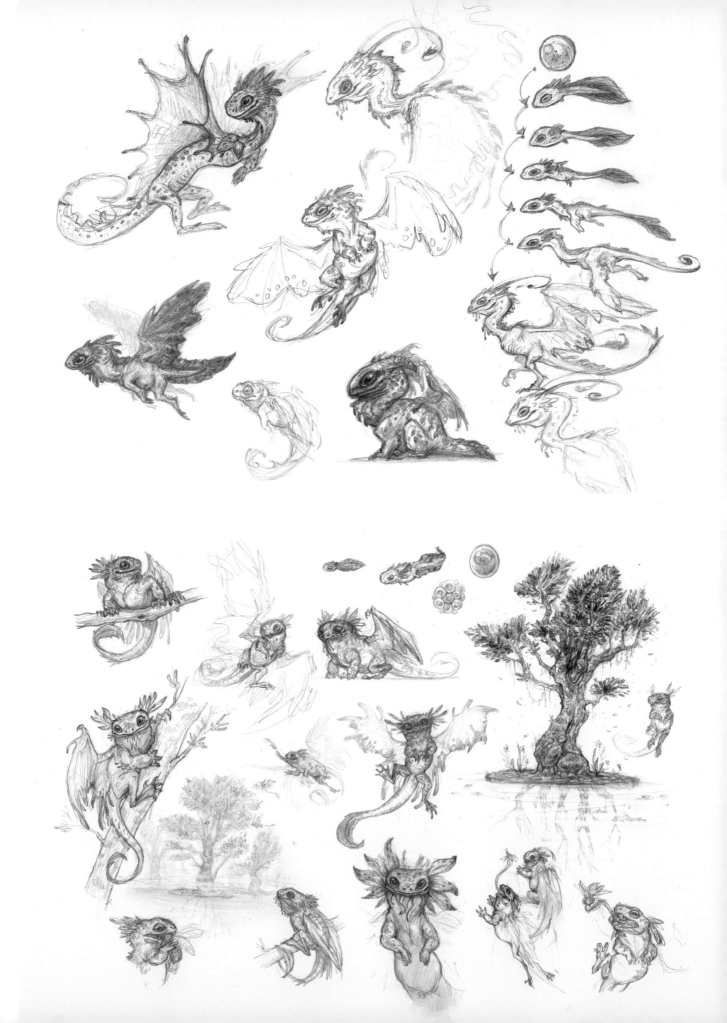

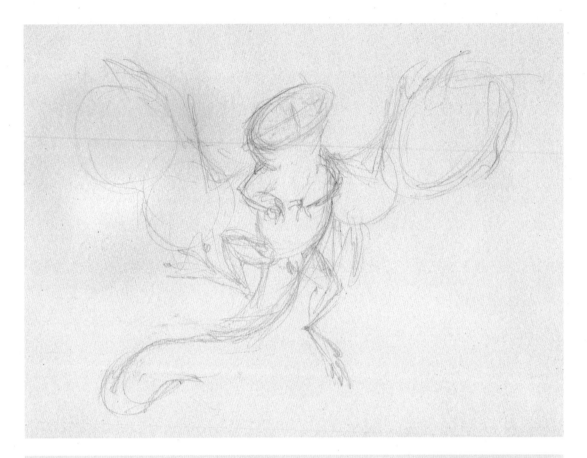

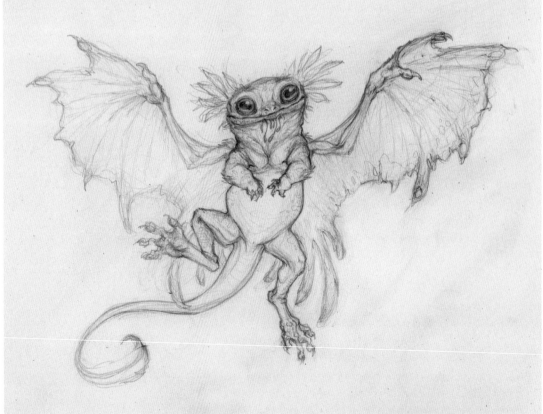

Top left
These first lines help to fit
the figure on the page, and
to mark the proportions
and directions of the body

Left
Defining the shape and
anatomy of the amphibian
dragon with an HB pencil

Top right
Applying shade with
an HB pencil: first a
general uniform midtone,
and then intensifying
the darker areas

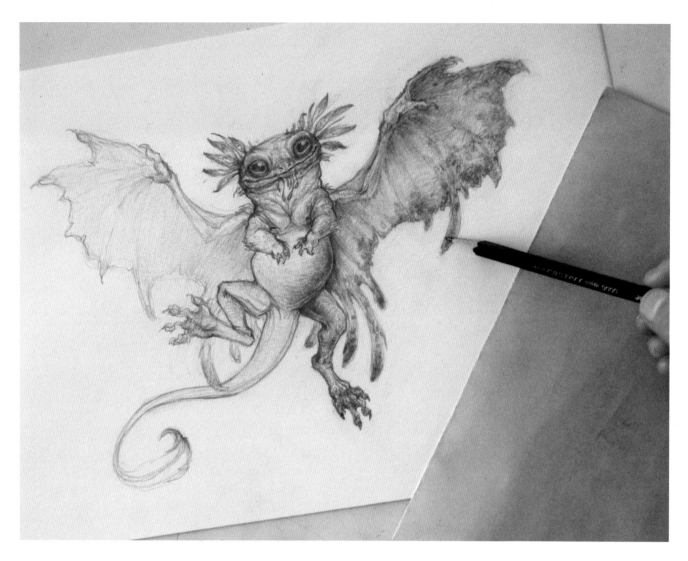

Quick base sketch

From the sketches made previously, I will carry forward the one of the small amphibious dragon that is facing forward with its wings outstretched, as it's a strong pose that shows the creature's whole body.

On a new sheet of paper, I start to draw some quick lines with which I frame the directions and proportions of the body without going into details. It is only a scribble, but it's important – it ensures that I will fit the whole figure onto the sheet, and that it will be composed to my liking.

Building up the drawing

Now that I have clear proportions planned out, I begin to shape the drawing with an HB pencil. At this point of the process, it is important to understand how the anatomy of the creature works. If there is anything you did not research in your earlier sketches, and you find yourself having a moment of difficulty with any part of the body, I recommend stopping to look up reference images of animals with similar anatomy. Analyze the references until you understand how the subject works, then apply this knowledge to the drawing.

First shading pass

Once I have clearly sketched out the creature's anatomy, I start with the first pass of shading. Still using the HB pencil, I apply a medium general tone all over the dragon's body. Above, you can see where I have also started applying a spotted pattern on the wings, which I will also apply to the body once I've finished the general shading of the figure.

ARTIST'S TIP

Clean work

It is ideal to have a piece of paper to lean your hand on while you draw, so as not to accidentally smudge the drawing. In general, it is very helpful to keep your workspace as clean and tidy as possible, allowing you to work more comfortably and avoid possible setbacks or mishaps.

ARTIST'S TIPS

Creating texture and volume

I shade using lines that follow the volumetric form of the body, as this organically adds texture and volume as I go.

In areas of darkness – on the sides of the legs, for example – I make small consecutive lines only in the dark area, instead of lines that run the entire volume of the leg.

Wing membrane texture

When shading the wings, I draw lines that run from the arm to the end of the wing. This creates the effect of folds or a membrane texture, as well as giving the impression that the wing membrane is attached to the arm. I also draw curved lines between the long fingers of the wing, following the shape of the membrane to give more volume to it. It is not necessary to draw these curves completely – I add them subtly in areas where the finger joints would be, to create the appearance of small folds where the joints of the wing bend.

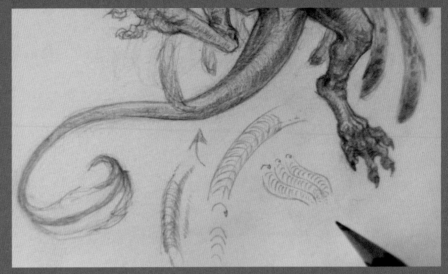

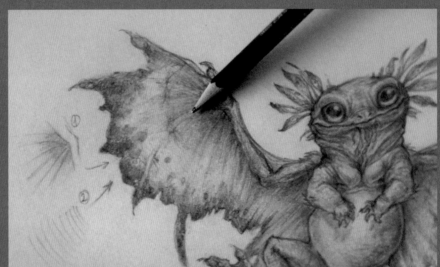

Shading progress, part 1

On the far top right, you can see the result of the first phase of shading. The dragon has a mostly uniform tone, except in some small areas where I have intensified the shadows to create volume and contrast. Observe the subtle shadow that the hands project onto the belly; this type of small detail, as well as the visible pencil strokes in the shading, will make the whole drawing feel more alive.

Shading progress, part 2

Now I want to add a mottled, stained pattern to the dragon's skin. Most spots would be on the dragon's back, but as we are viewing its ventral side, there will only be spots on its extremities, face, and the sides of its belly.

When applying a pattern over your previous shading, you must take into account the volume of the body and make sure that the patches and patterns adhere to this volume. It is important that the markings are more faint and subtle in brightly lit areas, and are darker in the shadowed areas, otherwise the creature's forms will lose credibility.

Top right
The result of the first shading phase, using only the HB pencil to generate different tones

Bottom right
Adding a mottled pattern to the dragon's skin creates a more realistic appearance

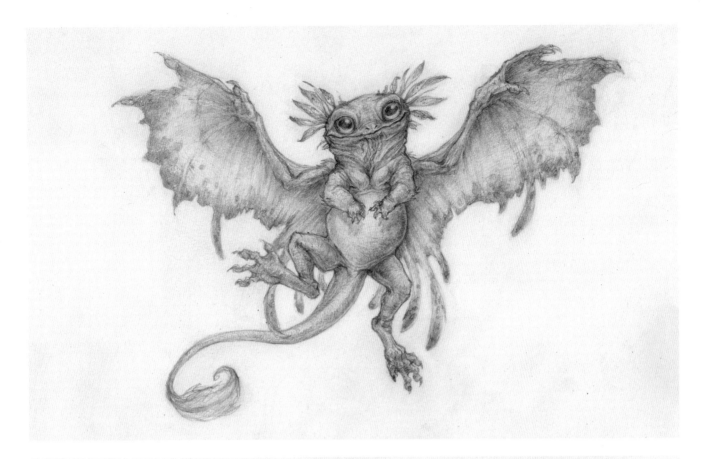

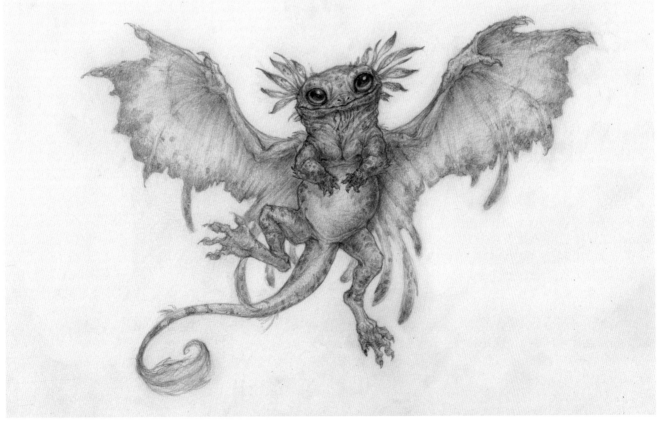

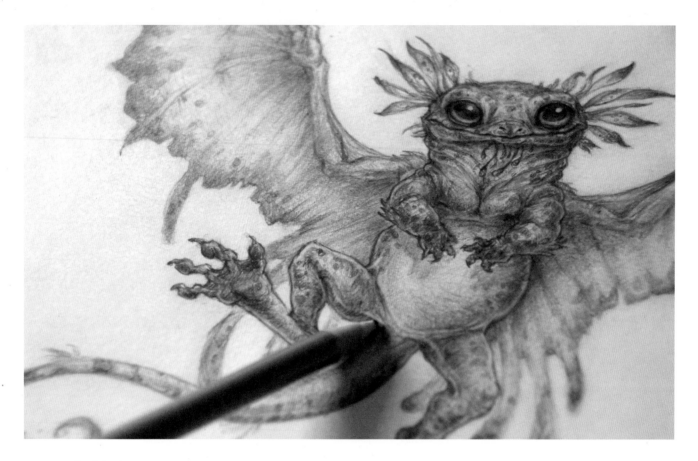

Contour highlights

I use the sharpened eraser to give subtle touches to some of the dragon's contours, and its body in general, creating the effect of ambient light reflecting on the body. Above, you can see where the highlights on the dragon's leg help to make the forms and folds of skin stand out more clearly. These touches of light greatly enhance the drawing and give it volume. At this point I also use the 4B pencil to darken some areas, like the shadows of the belly and pectorals, the folds of the neck, the face, and some of the skin spots that needed to stand out more.

Skin highlights

I use the 0.3 mm mechanical pencil to detail the smallest areas, such as the mouth and fingers, before picking up the electric eraser. I use this to apply little touches that simulate shiny skin in areas where the light strikes more intensely. If you don't have this kind of eraser, you can also make these highlights with a white pen or white marker.

Final clean-up

Before considering the drawing finished, I use the sharpened eraser to revisit the dragon's contours, cleaning up any blots and defining the outline better. I also erase or soften the contours that I do not want to stand out so much, as they are further away from the focal area, such as the end of the tail and the wings where they are overlapped by the dragon's back legs. I create this "depth of field" effect by pressing gently with the putty eraser on the areas I wish to lighten.

The finished image

The final result is this peculiar and amusing amphibian dragon. The plumes that come out of its head and tail simulate the leaves of the trees where it lives.

Perhaps it's looking for an ideal branch to hold onto, where it can attract some insects or small birds with the luminous lures that hang from its chin, and then use its long sticky tongue for capturing its prey.

Above
Using the sharpened eraser to get the effect of ambient light in the dragon's body

Near top right
Using the electric eraser to create the last highlight effects on the dragon's skin

Far top right
Cleaning up the outer contours with the sharpened eraser to eliminate smudged zones and better define the drawing

Bottom right
Final image © Ulksy

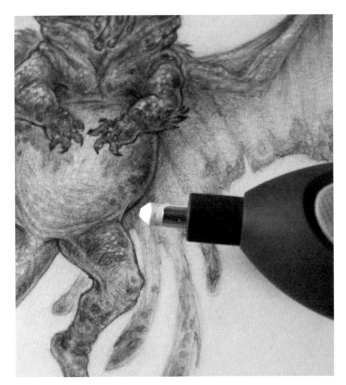

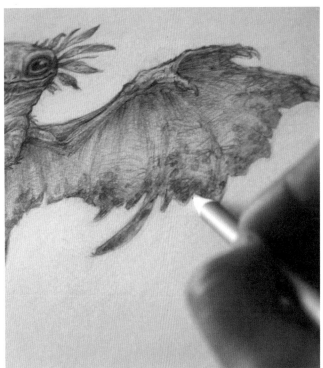

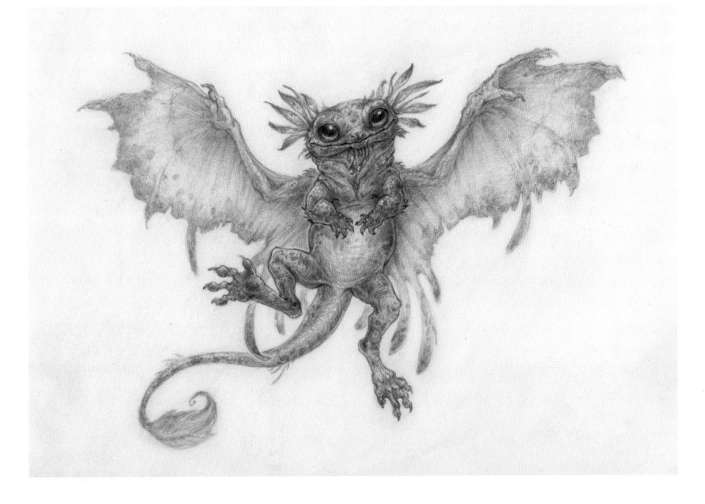

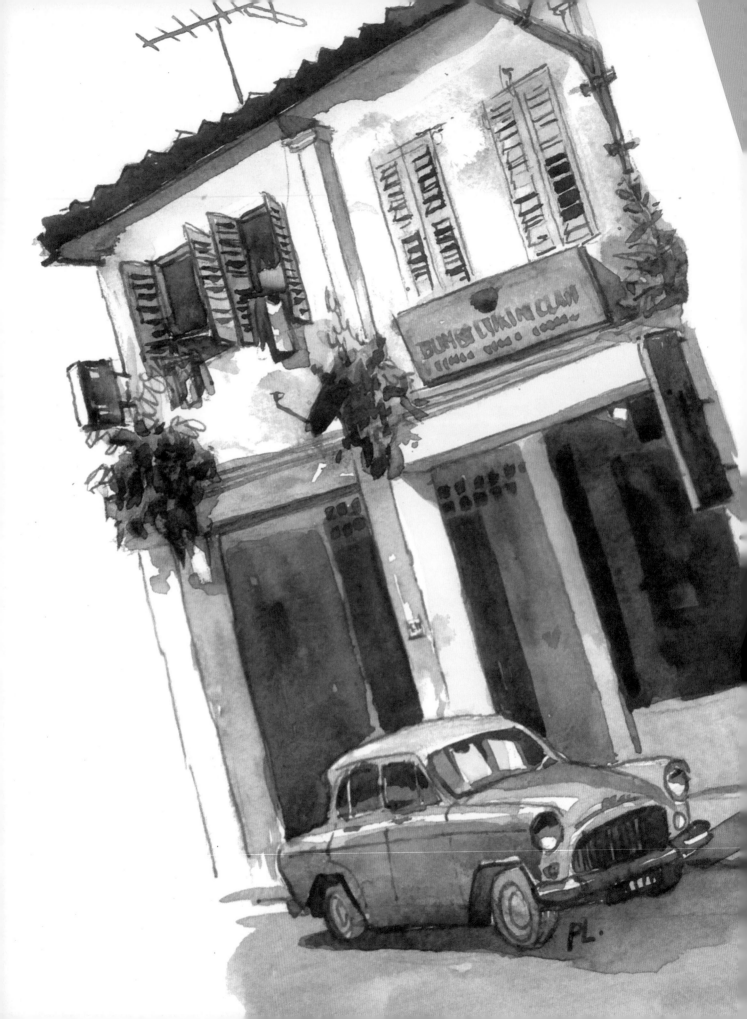

KUALA LUMPUR
IN COLOR

Urban sketching in watercolor and ink with Jason Chan P. L.

Jason Chan P. L. shares his observational sketching techniques while exploring the urban environments of Kuala Lumpur and Kuching.

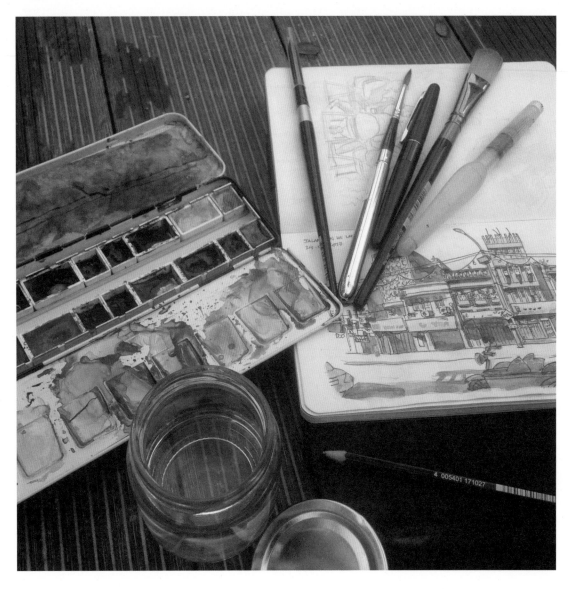

Left
My sketching tools

Top right
I always make a rough pencil sketch first, which usually takes ten to fifteen minutes

Bottom right
Testing color choices before painting

My name is Jason Chan Park Land and I am an animator currently working for Lemon Sky Animation, Malaysia. Despite now working for a 3D animation studio, I have had more than a decade of experience working in 2D animation, where drawing is a very important skill to have. That is why I draw whenever and wherever I am able to.

I remember drawing every single minute of the day from the age of seven because of cartoons and comics. I haven't stopped since

then, except when work and life get a little too hectic. I used to sketch to generate ideas, but now it is mainly for practicing gesture drawing and watercolors.

In 2013 I began to use my weekends to sketch people from observation. I would sit in a coffee shop for hours and draw the people around me, people walking by, and friends who'd join me occasionally. I continued doing this until I began following the work of Matt Jones (a story artist and urban sketcher). That

was when I learned about "urban sketching," but it wasn't until 2016 that I joined the Kuala Lumpur Urban Sketchers "sketchcrawls" after a friend introduced me to the group.

Sketching in my sketchbooks has become a form of journaling for me over the years. It's fun to look back through old books and remember when I made a certain sketch. It is much more entertaining than a simple photo taken with my phone, and there is always a story behind each sketch.

Tools

Just when I think I have narrowed down my specific tool kit, it evolves a little more. For drawing, my current setup consists of any 2B pencils, my Pilot Metropolitan pen, and a TWSBI Eco pen filled with waterproof Super5 Australia (maroon) ink.

I use an assortment of Daniel Smith and Holbein watercolor paints, with various size 6 and 10 round brushes, and a 3/4" oval wash brush which I use for sketches larger than A5 in size.

Building by the Klang River

November 11 2017 was the tenth anniversary of Urban Sketchers, and the Kuala Lumpur chapter celebrated by gathering along the Klang River to sketch. The building above was one that stood out the most on that day.

It was probably the yellow color, or perhaps it was how different it looked within the taller buildings around it.

"Sketchcrawls" are events involving meeting up with other urban sketchers to explore and sketch different locations for the day. On weekends, these gatherings are often only two or three hours long before we gather for group photos. Therefore, I must work fast if

I want to sketch more than one location. I have to think of how I can fit the subject into the dimensions of the sketchbook page, what I want the sketch to focus on, and what colors to use.

I don't have a strict structure or method when drawing perspective lines. I try to capture the essence of the subject instead of focusing on accuracy, so I tend to make some creative changes as I go. The colors are used to form the major shapes, values, and sometimes the mood and weather. It was a very hot day and this sketch really captures it!

I always apply the final lines with my fountain pen filled with maroon ink. It helps to hold all the loose colored shapes together, and the reddish hue of the ink gives an appealing touch to most color themes compared to using black ink.

Top right
When adding watercolor, I start off with the lightest colors and the darks of the windows

Bottom right
Adding details such as shadows and intricate objects such as the air-conditioner units, pipes, cables, and benches

Far right
I find clean and complete outlines very rigid, so I made the final outlines loose and sketchy.
Final image © Jason Chan P. L.

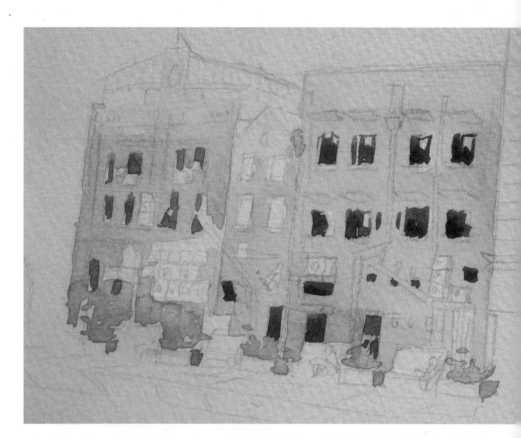

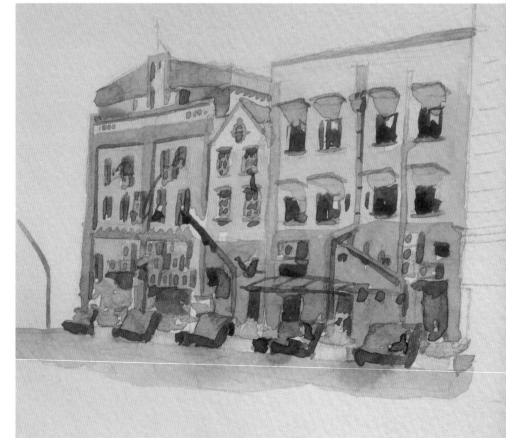

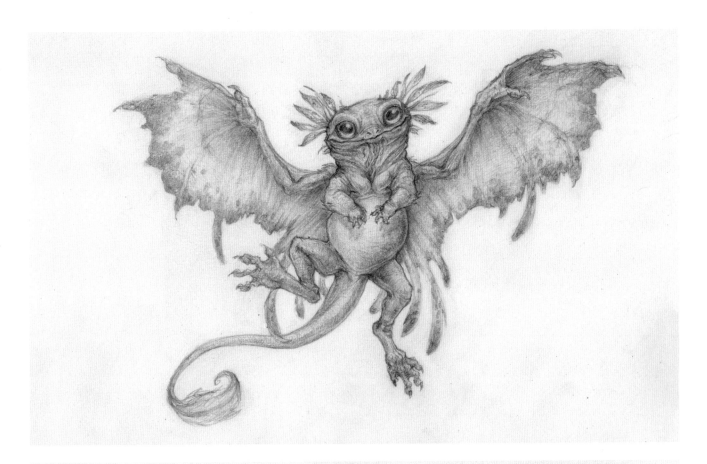

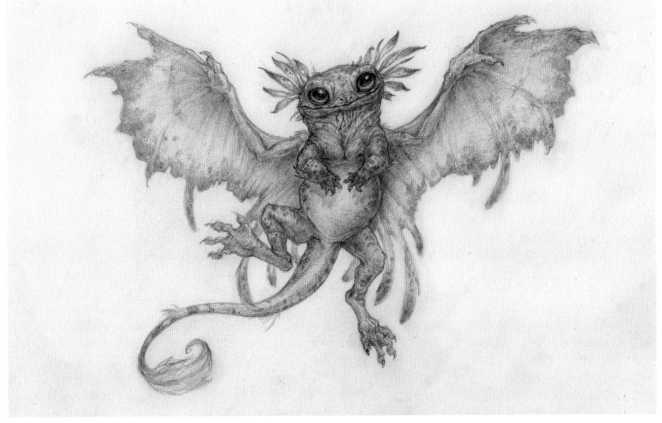

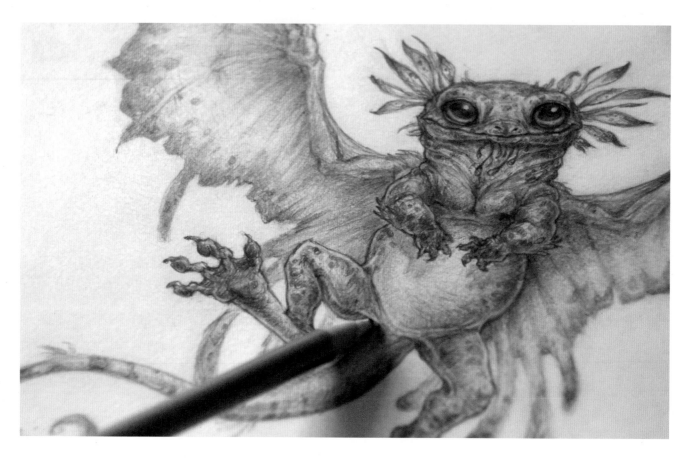

Contour highlights

I use the sharpened eraser to give subtle touches to some of the dragon's contours, and its body in general, creating the effect of ambient light reflecting on the body. Above, you can see where the highlights on the dragon's leg help to make the forms and folds of skin stand out more clearly. These touches of light greatly enhance the drawing and give it volume. At this point I also use the 4B pencil to darken some areas, like the shadows of the belly and pectorals, the folds of the neck, the face, and some of the skin spots that needed to stand out more.

Skin highlights

I use the 0.3 mm mechanical pencil to detail the smallest areas, such as the mouth and fingers, before picking up the electric eraser. I use this to apply little touches that simulate shiny skin in areas where the light strikes more intensely. If you don't have this kind of eraser, you can also make these highlights with a white pen or white marker.

Final clean-up

Before considering the drawing finished, I use the sharpened eraser to revisit the dragon's contours, cleaning up any blots and defining the outline better. I also erase or soften the contours that I do not want to stand out so much, as they are further away from the focal area, such as the end of the tail and the wings where they are overlapped by the dragon's back legs. I create this "depth of field" effect by pressing gently with the putty eraser on the areas I wish to lighten.

The finished image

The final result is this peculiar and amusing amphibian dragon. The plumes that come out of its head and tail simulate the leaves of the trees where it lives.

Perhaps it's looking for an ideal branch to hold onto, where it can attract some insects or small birds with the luminous lures that hang from its chin, and then use its long sticky tongue for capturing its prey.

Above
Using the sharpened eraser to get the effect of ambient light in the dragon's body

Near top right
Using the electric eraser to create the last highlight effects on the dragon's skin

Far top right
Cleaning up the outer contours with the sharpened eraser to eliminate smudged zones and better define the drawing

Bottom right
Final image © Ulksy

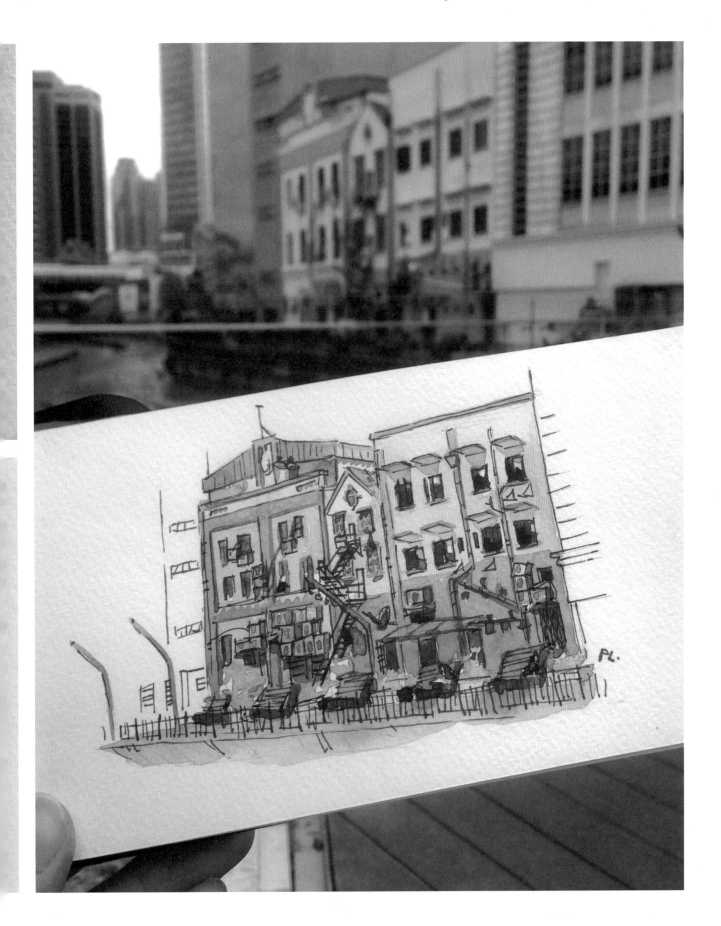

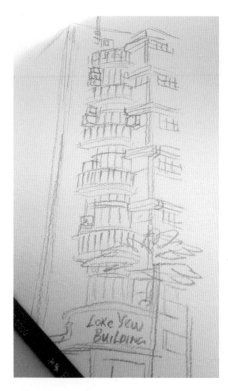
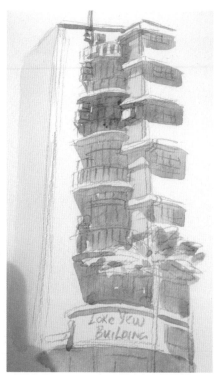
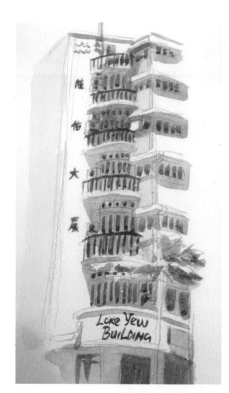

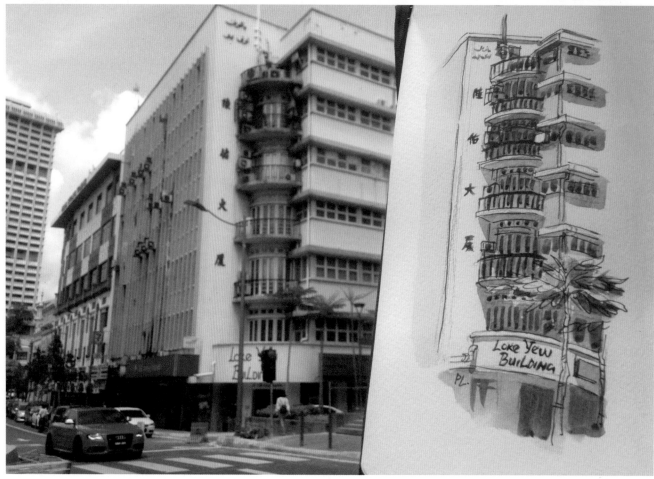

Loke Yew Building, Kuala Lumpur

There are times when I have very limited time to sketch. I had only 30 minutes to complete this sketch, so I had to narrow down my focus in the composition and stick to using only one color. My color of choice for this was Daniel Smith's Moonglow – a beautiful mix of purple and bluish gray. Sketching with one color also allows me to pay extra attention to shadows and values.

I had to finish the pencil sketch very quickly so that I had enough time to add the values. I admit that I was really tempted to spend more time getting all the details of the windows and balconies, but resistance is key when you are sketching in a hurry.

Whenever I can't get the details down in pencils, I can always add them during the watercolor stage, but I still try to keep my work loose and quick. It is the *impression* that is most important to capture. This has made me appreciate the Impressionists a lot more than I used to!

Far top left: A quick and loose 5-minute pencil sketch. The rounded balconies were a challenge to sketch accurately, especially when I had to sketch so fast!

Middle top left: I laid down some quick blocking of the building's cast shadows, such as the hard shadows of the balconies. This stage is very satisfying when it turns out right, as the sketch begins to take on proper form

Near top left: Adding more details and values. I love how signage makes a location sketch look authentic

Bottom left: I usually choose black ink pens for finishing monochrome sketches, but in the case of this spontaneous sketch, I didn't have one with me. Instead I used my usual maroon ink pen, which gave the sketch a little more color that made it interesting.

Right: Final image © Jason Chan P. L.

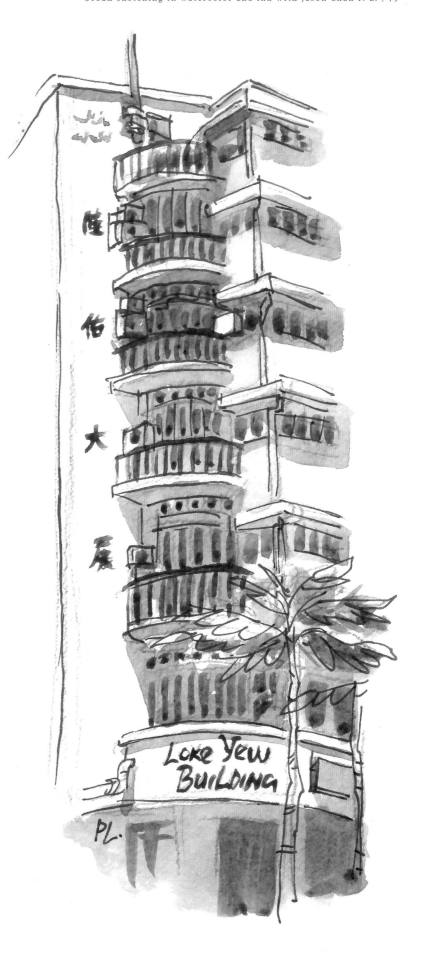

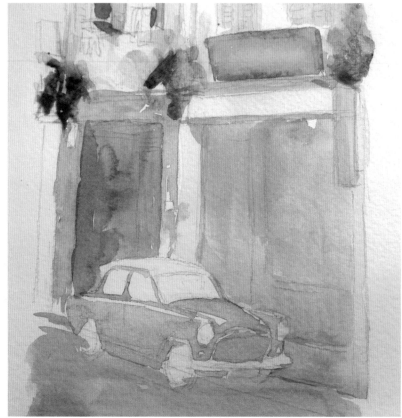

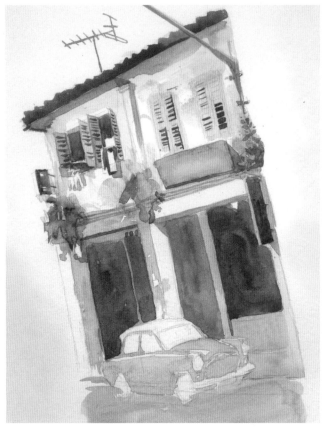

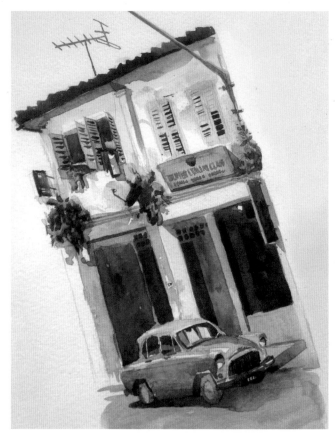

1961 Simca in Kuching

I usually sketch with A5 sketchbooks or watercolor papers cut to a similar size, but for my recent sketch trip to Kuching (Sarawak, East Malaysia), I tried a Kami Art 15 × 37.5 cm watercolor sketchbook. The bigger size was intimidating at first but it turned out to be rather fun. The panoramic dimensions of the book when used vertically helped (or forced) me to focus on framing and composition, like in this sketch.

I came across a beautiful blue 1961 Simca Elysée parked in Jalan Ewe Hai, a street filled with shophouses which I believe were built in the late nineteenth century. The setting was perfect and I had to sketch it. Sketching old buildings is always more fun than sketching clean and modern architecture, because the messy details of a worn-down building have much more character.

Far top left: I kept the sketch of the Simca simple and focused on getting the details of the traditional windows. I left out a lot of the ground details in the pencil sketch, intending to take care of them with my watercolors later

Near top left: As always, I started with painting lighter colors and blocking out some basic shadows. I added in some details along the way, such as the antenna

Far bottom left: I layered in more saturated areas to make the sketch more aesthetically pleasing. I like to let my colors mix on the paper so that the final sketch will have interesting color textures (such as the display windows, roof edges, and the back of the car)

Near bottom left: I found myself getting a little carried away with details! When I painted the Simca, I made sure to leave white areas that created metallic highlights

Right: When it came to adding the final touches, my Pilot Metropolitan pen ran out of ink! It's a good thing I always carry my TWSBI Eco filled with the same ink as a backup. Final image © Jason Chan P. L.

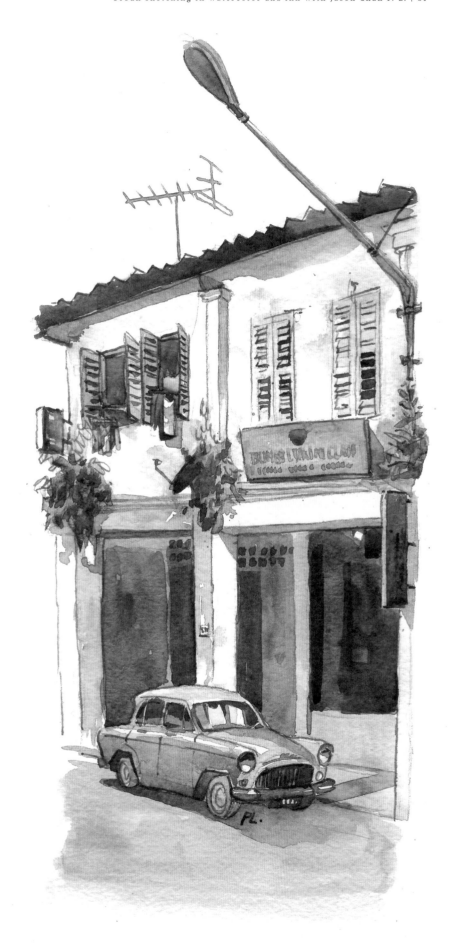

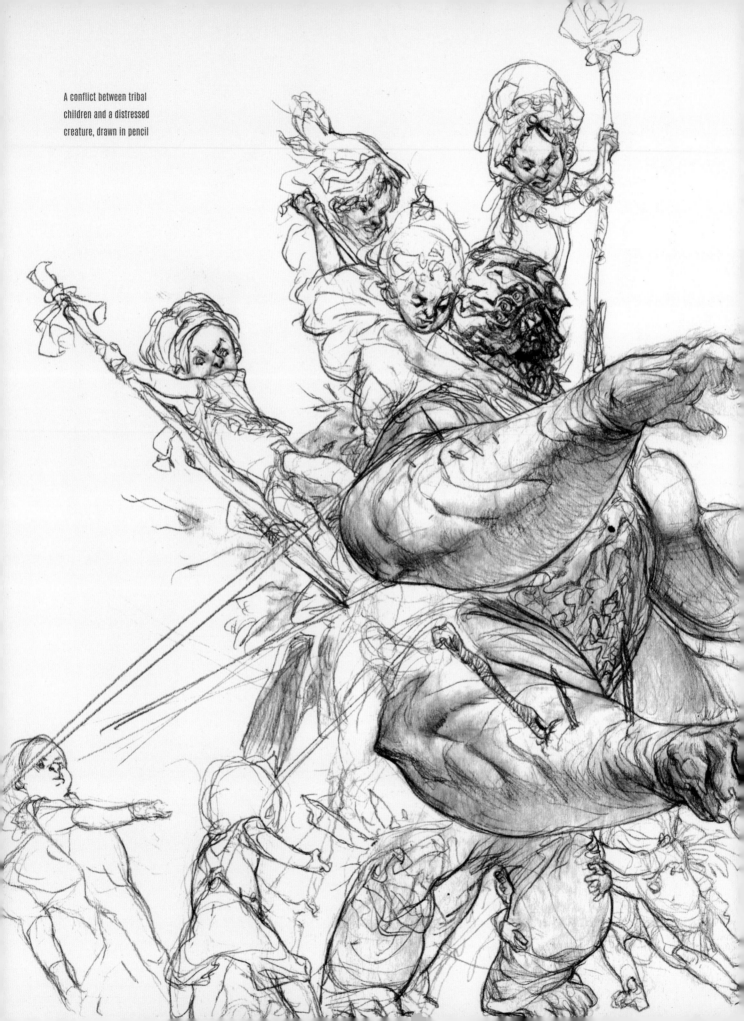

A conflict between tribal children and a distressed creature, drawn in pencil

THE
DRAFTSMAN

An interview with João David Fernandes

João David Fernandes is an illustrator and concept artist with a flair for striking, dynamic characters. We learn more about his work in this interview.

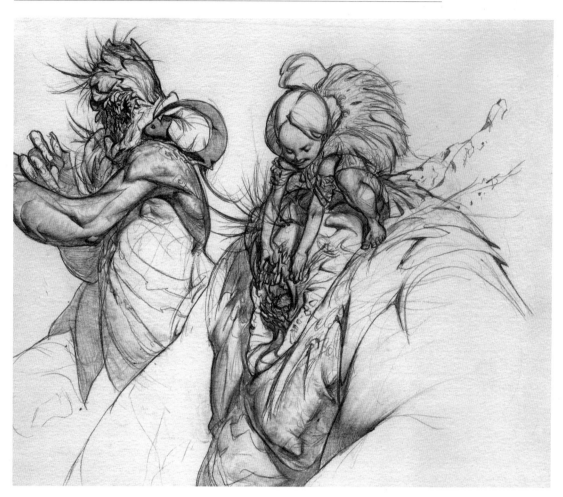

Left
A base sketch for a digital painting, in pencil

Right
Some explorations for wasteland-dwelling characters, rendered with pencil and smudging

Q· Thank you for speaking to GRAPHITE, João! Could you please introduce yourself with a bit about what you do, and where you're based?

A· I am currently working as a freelance artist in Lisbon, Portugal, where I was born and raised. Throughout my journey, I have mostly focused on personal work, only recently taking a more public, professional approach. If anything, I am merely a passionate draftsman, and have been trying to set myself up for becoming – maybe, in time – a better creator in as many mediums and formats as I find I want to learn, however long that might take. But, so far, I will only claim the label of a draftsman.

Q· When did you decide or realize that you wanted to pursue art as a career?

A· I could divide this into two specific major phases, the first one being my early childhood. My parents and everyone around me must have told me I was a good artist as a child, and like most children, I just went with it.

Being in such an environment for most of my life, and compulsively and repetitively playing certain games and watching certain shows, distanced me from most paths except art. I was mostly clueless about how and where I would fit professionally, but for some reason I still felt secure in my future.

It was when college came around – as I'd been having the usual growing-up self-esteem issues due to the most frivolous of reasons – that I truly felt compelled towards something that would occupy my life from there on.

Which leads to my second phase, where I began to meet amazing new people. These people were my age and had just been to their second Trojan Horse was a Unicorn (a massive art event held in Portugal). I learned about the huge industry of entertainment art and its biggest artists, and I started admiring the artists I could and am still striving to become, not only because of their art, but who they are as people.

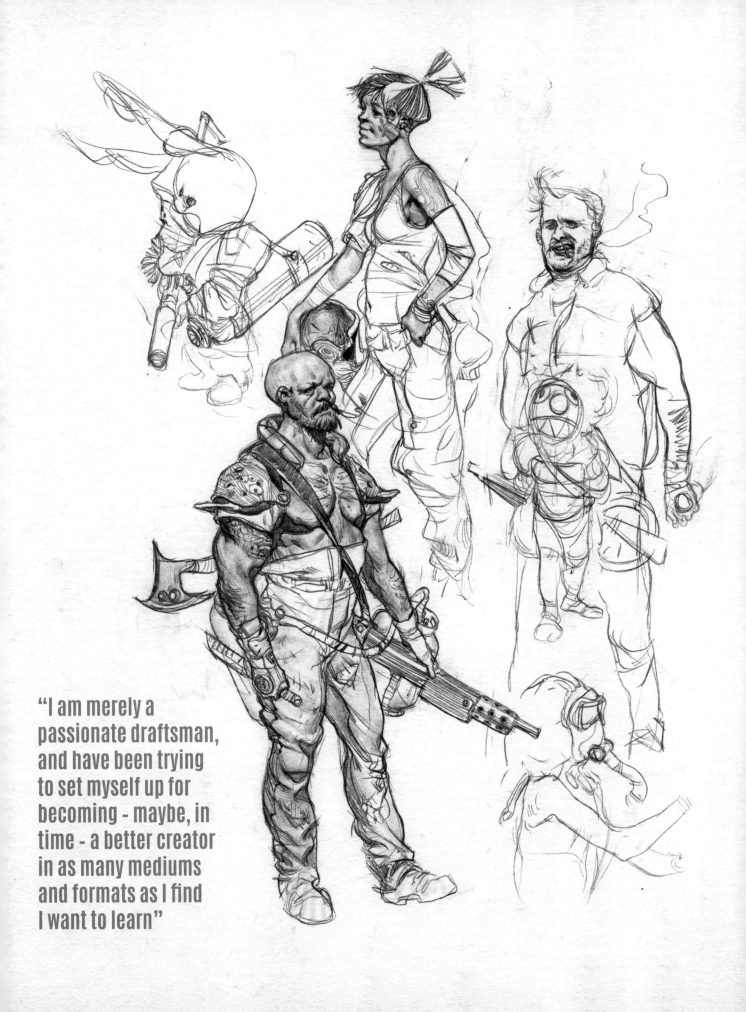

"I am merely a
passionate draftsman,
and have been trying
to set myself up for
becoming - maybe, in
time - a better creator
in as many mediums
and formats as I find
I want to learn"

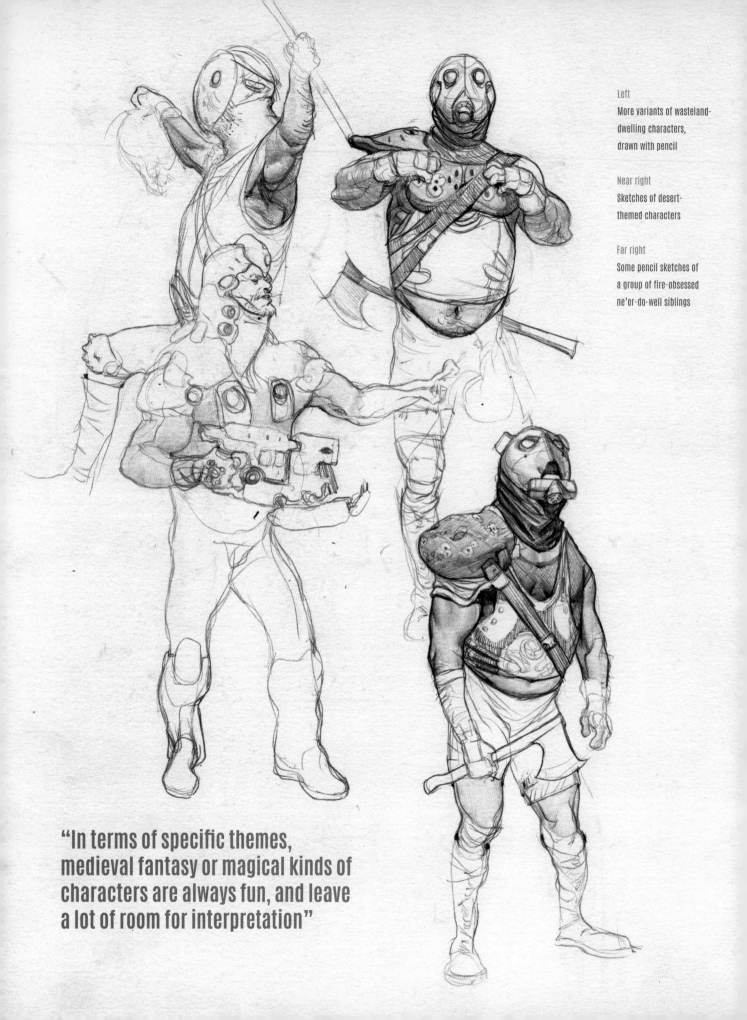

Left
More variants of wasteland-dwelling characters, drawn with pencil

Near right
Sketches of desert-themed characters

Far right
Some pencil sketches of a group of fire-obsessed ne'er-do-well siblings

"In terms of specific themes, medieval fantasy or magical kinds of characters are always fun, and leave a lot of room for interpretation"

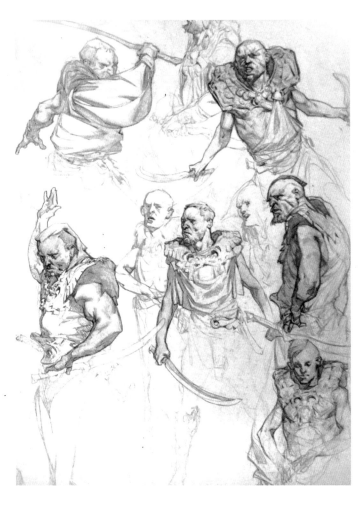
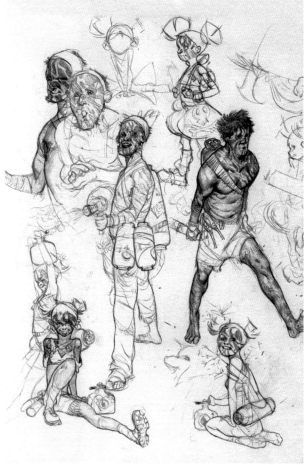

Q· Who or what would you say are your major creative inspirations?

A· I would always start with Alexander "Zedig" Diboine. I saw him, from the start, as someone unbound by the idea of only doing one thing, or representing it one way, while still being a great artist, whether you look at his animations, concepts, illustrations, or comic stories. I must also reference Even Mehl Amundsen, whom I've had the pleasure of meeting and whose art has always inspired me greatly. Just as important are artists like Mike Azevedo, Ramon Nuñez, Iain McCaig, Kim Jung Gi, and others.

I am also inspired by heroic tales like *Dragon Ball*, and hilarious and nostalgic cartoons like *Ed, Edd n Eddy*. More recently, animations like SunCreature Studios' *Tales of Alethrion* have been massively relevant to me.

And obviously, I am inspired by some of my closest friends who share this artistic journey with me, as well as all of my family who pushed me towards this and encouraged my creative growth since I was very young. The people and sources I have mentioned inspire me to try to be just as genuine, virtuous, fun, and engaging with who I am and what I create.

Q· What are your favorite subjects to draw? What really makes a concept fun for you to work on?

A· Anything that I feel is serious but can leave some room for a comical or laid-back aspect. In terms of specific themes, medieval fantasy or magical kinds of characters are always fun, and leave a lot of room for interpretation. Both heroes and villains can be interesting. I particularly like contrasting funky, menacing

creatures with a more relatable human character, often an expressive adult or a child, as it is always fun to figure out their actions and emotions.

Q· Your characters and concepts have such a vivid sense of form and anatomy. How have you approached learning about anatomy and the figure?

A· For the longest time, I mainly relied on what I saw in everyday life, and looking at artists I thought were strong in these aspects. I tried to force myself to learn a lot with my subconscious, but at some point I felt I needed to actually study anatomy, and I did, which improved my drawing a lot.

Just recently, I began studying with a great artist who is now also a good friend of mine, and I have been able to piece together the

ways and habits I need to improve. I have been trying to discard my bad habits and, better yet, control the good tendencies I already have. I am also trying to learn a more structured way of thinking about my drawings, instead of relying so much on pure intuition.

Q· What tools and materials do you prefer to sketch with?

A· Any tool that is immediately capable of leaving a strong mark is good, as it makes the whole drawing potentially come alive much faster, and in turn be more interesting. A ballpoint pen or darker pencil is great for this. I use a mechanical pencil the most, and do not normally add colors.

To quickly render a range of tones, anything that serves as a smudging tool is particularly useful. Fineliner pens, markers, and brush pens are fun to use as well, especially to change my thought process a bit.

Q· What is your typical approach when creating a new concept or character?

A· It significantly depends on the purpose as, for the most part, I've mainly valued feeling good about what I draw, and just having fun when working on personal projects. I picked up the (not at all fruitful) habit of jumping straight into sketching, figuring and re-figuring things out halfway through the process, being more concerned with the overall shape and look while potentially disregarding function.

Now I try to go back and forth between planning and thinking more deeply about what the concept is, and only then do I actively choose to bring it to paper. For me, the process is still very much about overcoming the immediate subconscious tendency to have fun drawing, and instead seeking the whole build-up and thought process that is important for transmitting a message and story.

Q· What are some of the challenges and advantages of being a freelance artist?

A· A lot of the major challenges of being a freelance artist stem from what I would also consider to be its major advantages. Being free to, at any point, shift your focus to other work, determine your own schedule, and manage your time according to your preferences is a benefit. However, this can just as much lead to an unorganized attitude, demotivation, and essentially falling into your own mischievous logic – things that I am all too familiar with!

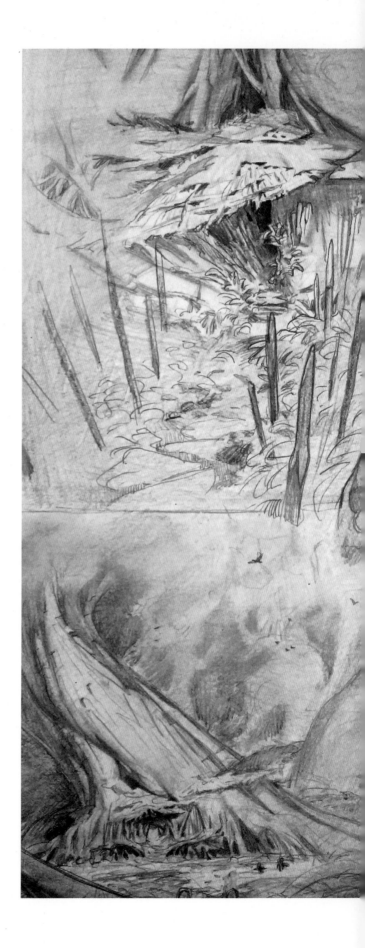

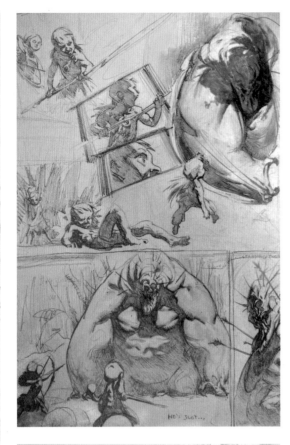

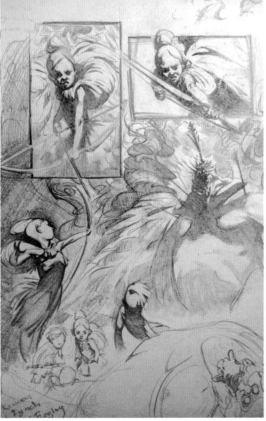

Often I set myself up for mistakes and bad habits, excusing them as being "detours that I must take from working too hard," or "searching for inspiration in movies, games, and of course, YouTube videos." Sometimes I might not prioritize deadlines over personal work that I *absolutely must do* after seeing one too many ArtStation updates! In the end, just as I would say for anything, it is important to try to stay sharp and alert, not only regarding your work but regarding yourself.

Q· What is one important thing you have learned in your career so far?

A· Honestly, it would be something that I have only learned recently, that is now reshaping what art is for me. Art is a great path to follow, but as soon as you recognize that you want to *tell* something with your art – the whole notion of finding out who you are and why, and why people have been enacting myths, religions, and heroic tales in many art forms – it can become one of the most engaging things you set yourself up to do. As important as the technical aspect might be, figuring out *what* I am actually seeing around me, and what people react to, has proven to be immensely more useful and pertinent to me as a creator or storyteller. It's a lot more fulfilling.

Q· What do you like to do when you're not making art?

A· This goes somewhat in tune with my previous answer, in that I've been trying to put more time into reading different types of articles and excerpts, and listening to a lot of podcasts and interviews, whether they are related to current topics or just philosophy and psychology throughout history.

I also relax by watching movies and chatting with friends, and sometimes I'll get addicted to a video game in a very regressive manner! I try to work out or pursue a sport if I have the chance. And I love watching football. The real football.

Far left
Pencil sketches of some different environments

Near top left
A rough draft of a hunting scene, from a project
rendered further in pencil later on

Near bottom right
Another draft of the sequential moments
from the previous hunting scene

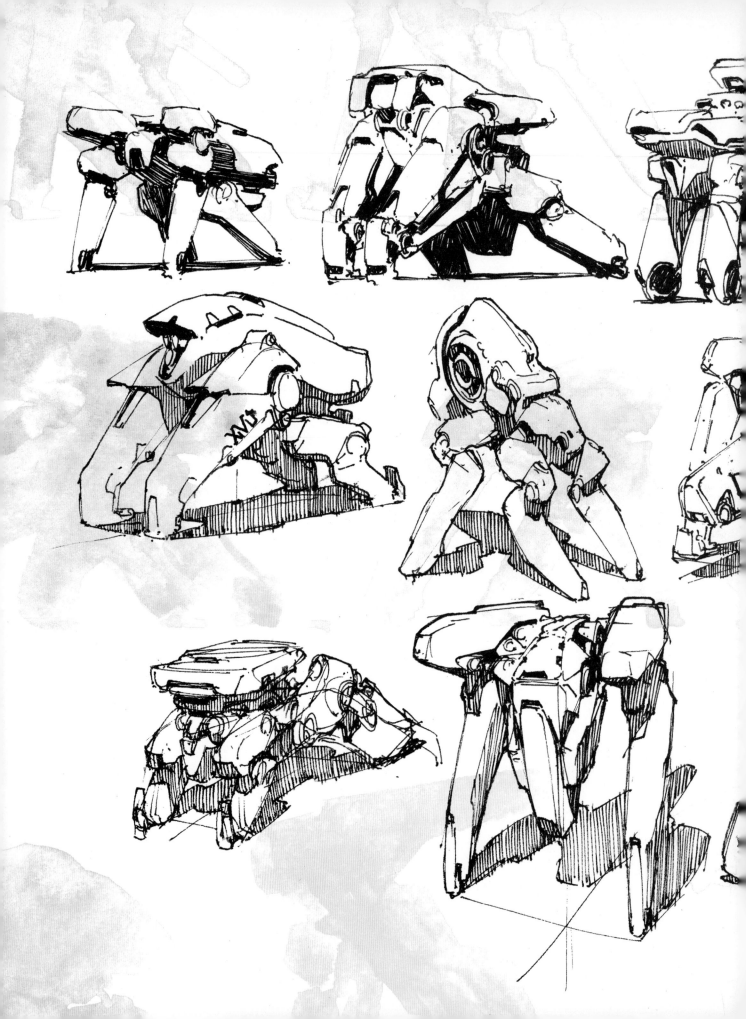

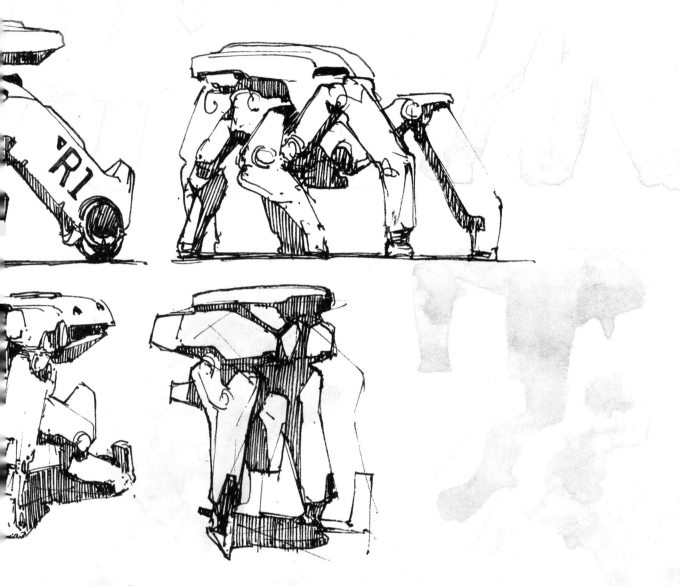

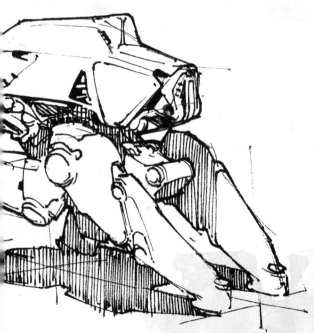

MARK-MAKING
MECHS

Sketching and concept design with Nikolay Georgiev

Concept artist Nikolay Georgiev shares his process for developing and drawing sci-fi designs using ballpoint pen, watercolor, and markers.

In this article I will present a robust method for designing mechs with a ballpoint pen, marker, and some watercolors. The tutorial has a strong focus on commitment to mark-making, so pursuing this style should, over time, teach you the importance of a steady hand and learning from bad decisions, rather than correcting them immediately. I hope you will enjoy experimenting with this technique, find your own way of doing it, or simply improve your process. The most important thing is to continue drawing.

Materials overview

My main materials are an A4 Moleskine watercolor sketchbook, a Pentel waterbrush, a ShinHan Green Gray 3 or Cool Gray 2 brush marker, a Mitsubishi uni-ball Micro pen, and a Bic ballpoint pen. I would like to put an emphasis on the ballpoint pen: it's an old-school ballpoint, not a modern gel pen. The thick ink provides a lot of finesse when drawing, making it possible to build up from very light to very dark lines. I will elaborate on the advantages of these tools below.

Tools for fine detail

I have tried many different pens over the years – gel, ink, fineliners, brush pens – and have discovered that the simplest classic ballpoint pens offer the best detail and control for my type of sketching. The uni-ball I use is also a ballpoint pen, but uses runny black ink and generally leaves a pure black line, no matter how thick it is. I find it useful for quick thumbnail sketches, when I don't want to be sucked into being careful and slow, or want to add some opaque shadows or extra thick outlines to a design. The ruler is not mandatory, but if you decide to add a black box for a backdrop, like I will in this image, then the ruler is your friend.

Tools for shading

Light gray markers are ideal for capturing the design's proportions, perspective, and gesture, without getting distracting black lines all over the final design. I personally love ShinHan markers and find that their brush tips are perfect for sketching gestures, as even the freshest marker, when used with fast

Far top left
The main tools used
for this project

Middle left
These pens are masters of
detail and commitment

Near left
ShinHan and Copic Sketch
markers offer a feather
touch for your shading

Far bottom left
White is useful for adding
specular highlights

Top right
A selection of waterbrushes

Bottom right
Tasty colors - do not eat!

strokes, leaves a slightly drybrush-like mark. An alternative range is the Copic Sketch series (in Cool Gray, C1 or C2).

White for highlights

When aiming for a partially shaded finish such as this design will have – or any tonal treatment on a design – nothing brings more "bling" than a white highlight on a sharp metal edge.

For highlights, you can use any good white comic-book ink, acrylic, or gouache. It doesn't really matter, as long as the white stays opaque when applied to the drawing. Consider whether you would like to blend or water down the white highlight after it has

dried, as comic-book ink does not lend itself to manipulation after it has dried as well as gouache. The white ShinHan Poster Color that I will use, pictured on the far left, has a vibrant opaque finish.

Waterbrushes

I like using a waterbrush, as the water tank helps to keep the brush consistently wet, and it can be used to blend watercolor very finely. For this tutorial I will use only two of the pictured brushes – the large fine point and the smallest one – as I won't be using a lot of colors and will have to do some extremely precise painting. Out of the other brushes, the flat one can be useful for creating thumbnails, as it provides a much-needed structure to an

otherwise very small and fast sketch, which can give a good sense of shape or perspective.

Watercolor paints

Watercolors are not extremely important for this tutorial, as the design won't utilize a lot of color, but they will give a texture to shadows that markers can never really achieve. Good quality watercolors blend well with paper, don't leave dusty particles after they dry, and do not stain other pages. Don't buy children's paints; you do not need the most expensive watercolors, but having something of decent quality will help. I use White Nights' set of twelve in a plastic container, as I have used them since high school, and they are very easy to carry around.

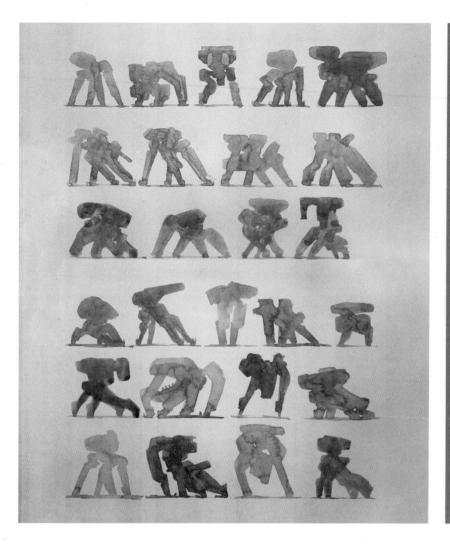

Above
Getting in a creative
mood with silhouettes

Right
Testing out the best
ideas in pen

ARTIST'S TIP

Using silhouettes effectively

One important point when sketching silhouettes is to avoid using profile views. Working in a side view reduces your chance of creating interesting overlapping shapes, and you must commit to deciding what is the front and what is the back of the design. When a three-dimensional shape has no interior detail, just looking at it and finding multiple ways to interpret it can spark your imagination.

To make an argument for choosing watercolor over pure black brush pen, I enjoy using watercolor because the different colors and transparencies give a different flavor to each shape. If you're really proud of your silhouette skills, you can even decide to add darker colors or white highlights to the design. Black ink is heavy and imposing, and if you create a lot of silhouettes on a page, you can end up overwhelmed by the intense contrast of black and white.

Silhouette thumbnails

I tend to start a design by creating silhouettes in watercolor or black ink with a brush pen. It is a fast and easy way to explore a great variety of ideas without being too careful or focusing on perspective. Many concept designers will agree that the first ten to twenty silhouettes you make will be very much within your comfort zone: ideas that you've already seen and already know. To get past this stage, try to make as many thumbnails as you can until you start repeating yourself. This is how you will consciously start trying different ideas, and that is where good concepts come from. When you become experienced and draw a lot of ideas over time, it can be harder and harder to get out of your comfort zone, but using a familiar shape to create something fresh is a challenge that has its own charm.

Test the best

After you have satisfied your curiosity with silhouettes, you have probably decided on a few shapes that attract your eye the most, or that you see the most potential in. You may have already identified areas or aspects of the initial shapes that work well, and maybe others that you think can be improved to get a better gesture, proportions, or to just generally improve the silhouette.

In this step, use a gel ink pen or fineliner to see what further ideas can be developed based on those shapes. Try drawing quick line thumbnails, working out basic forms and perspective without going into too much detail. Adding a rough shadow shape and cast shadow helps to ground the design in space. This is where the overall "shape language" of the design is conceived: for example, rounded and organic, or angular and synthetic.

When sketching the design's surfaces, try to contrast areas of visual rest and areas of denser detail. This is also an opportunity to try placing big decals, names, or logos. When you become more accustomed to sketching like this, you can also try out different angles of joints and systems of movement to see if your design makes sense before you commit.

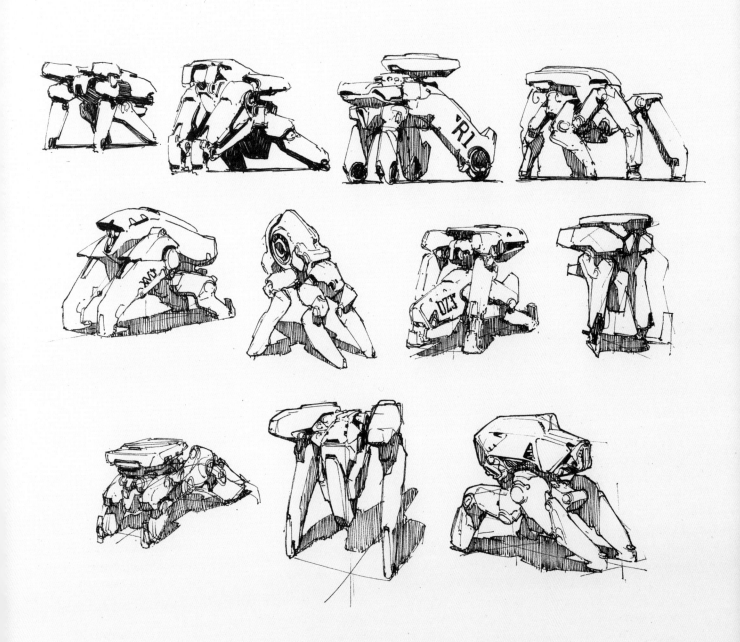

Gesture, perspective, and proportions

There are three main aspects you need to secure before you commit to detailing your design: gesture, proportions, and perspective. *Gesture* is what makes comic books dynamic, and great character concept art stand out from good character concept art. Even if a robot is only standing, you don't want it to look stiff and boring! Think of an animation or movie poster that you like and try to capture the same sense of flow and pose in your sketches.

Indicating some loose *perspective* lines will give you a good sense of how your pose sits in space, to figure out the design's center of gravity, and where its legs hit the ground. The cornerstones of a convincing pose are good contact with the ground, and a sense of balance so that the design doesn't look in danger of falling over.

Finally, make sure you translate the *proportions* well when scaling up your drawing. When drawing at a small scale, we often exaggerate proportions so that they are visible, and when drawing on a bigger scale, we tend to reduce extremities, as our attention goes towards smaller details and shapes. Sometimes the initial exaggeration is what made the shape so special, so make sure it is not lost.

Design aesthetic

Now it's time to pick up an old-school ballpoint pen and start to flesh out the design. Maybe until now you haven't thought about your concept in too much detail, though you may have a rough idea. Perhaps you want it to be steampunk, or a very slick luxury mech; maybe you want to show a lot of exposed mechanical parts, or maybe you want to focus more on the paneling and paint job. Whatever you choose, the first ten or fifteen minutes are crucial, as that is when you establish the type of detail and aesthetic the design will have until it is finished.

Ballpoint sketch

Spend some time figuring out the concept's joints, hinges, and transferable details (elements that you would need to draw at least twice from different angles). Find the repeating elements to make sure you are detailing the design consistently, and maintaining your chosen style.

Using the ballpoint pen is valuable during this stage, as it allows you to make very light marks to explore lines and describe planes that might prove useful. Sometimes you can even test out some details and abandon them if you find they are not working.

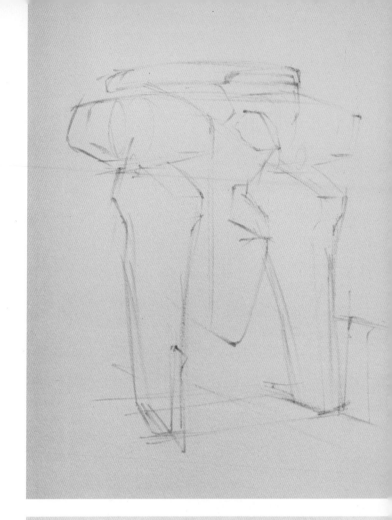

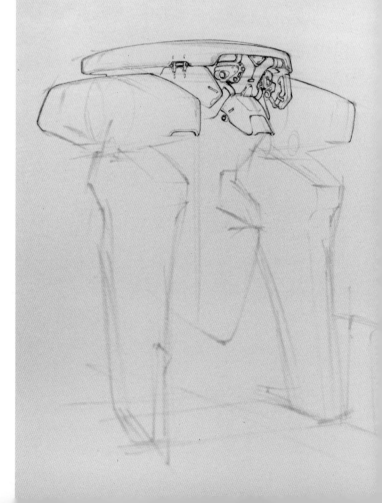

Finishing the lineart

This stage is self-explanatory: keep up the linework until you reach a well-balanced, detailed design that you are happy with. Ideally you would be completely satisfied, but another part of this technique is learning how to own your mistakes and keep them as lessons. Perhaps you made an element that you don't like, or a detail that you wish you could change – but most importantly, you have committed to something, and that small detail will be there as a reminder to always think and consider your choices. If you are not certain about adding something, sketch it on separate paper to test how it works before adding it to your final design.

Far top left: Gesture, proportions, and perspective

Far bottom left: Committing to a design aesthetic

Below left: Adding more details in pen

Below right: The finished ballpoint line work

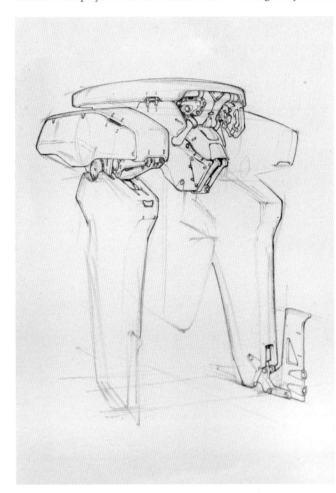

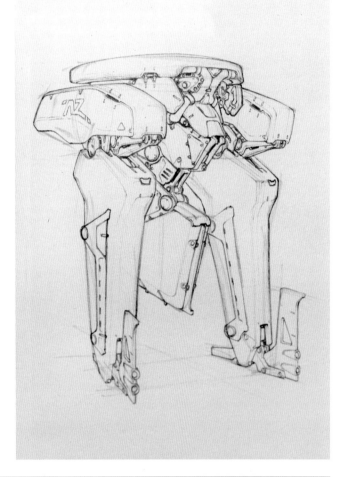

ARTIST'S TIP

Designing "faces"

A good design practice when trying to add personality and flare to a mech design is to consider its "face." If you design the mechanical parts to resemble a face, it helps the viewer to connect with the design, like it's a pet. But also consider *not* having a visible face. Moving machines with legs always give an impression of life, because many of the mechanics they utilize to move are based on animal or human anatomy and logic. If your concept already looks like something living, leaving a blank area where the face would be can give the design a completely different feel. A blank face makes a design feel cold and unrelatable, even unsettling or intimidating, which you can use to your advantage if this is your intention for the design.

Introducing shadows

Now I will use watercolor and a waterbrush to start adding shadows to the design. Adding a shadow pattern and cast shadow can be tricky if you are not used to plotting out shadows, but everything is a lesson. When you are starting out, you can try to plot your shadow loosely with a mechanical pencil to see if it looks right, but don't worry too much – it does not have to be extremely accurate.

I tend to choose the shadow color based on any graphics I have planned for the mech, or if I don't plan on any of those, I choose a color that feels natural, such as a cool shadow to suggest sunny lighting. In this case, I plan for the logo on the robot's leg to be red-orange, so I choose a complementary blue-green color for the shadows. Make sure to test out your watercolor, ensuring the desired opacity, value, and saturation, before applying the shadows.

Adding midtones

Let's further flesh out the design's forms with a midtone color. You can convey the same type of information with gray markers, but using watercolor gives the image much more personality and texture. In this case, I use a lighter version of the same blue-green shadow color, as I am aiming for a more stylized, monochromatic look with a color accent.

At this point you can take various routes with your color choices. You can try to enrich the lighting by adding more warmth to the midtone, suggesting the sun color. Alternatively, you can create a wash that would suggest the local (flat, unlit) color of your materials. If you choose the second option, consider that the introduction of the local color in the midtone would also affect the shadow colors, otherwise the design would feel detached and unconvincing. As far as technique goes, you can play with the harshness of the edges by using a clean brush to blend some of the edges slightly. This creates a variety of soft and hard shadows in your image that you can use to guide the viewer's attention, or just to describe the design's form better.

Right: Starting to add shading to the design

Far right: The design with midtone colors added

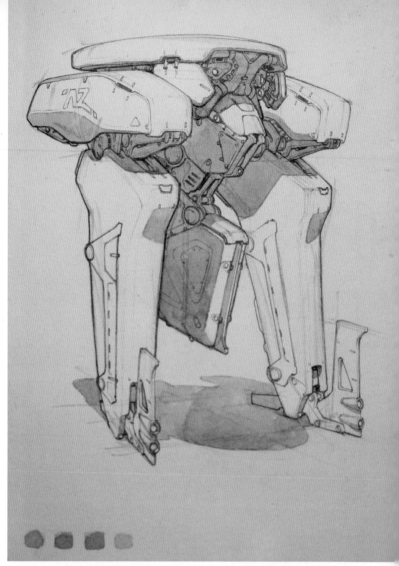

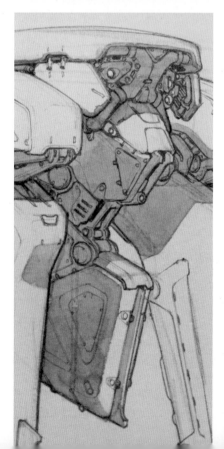

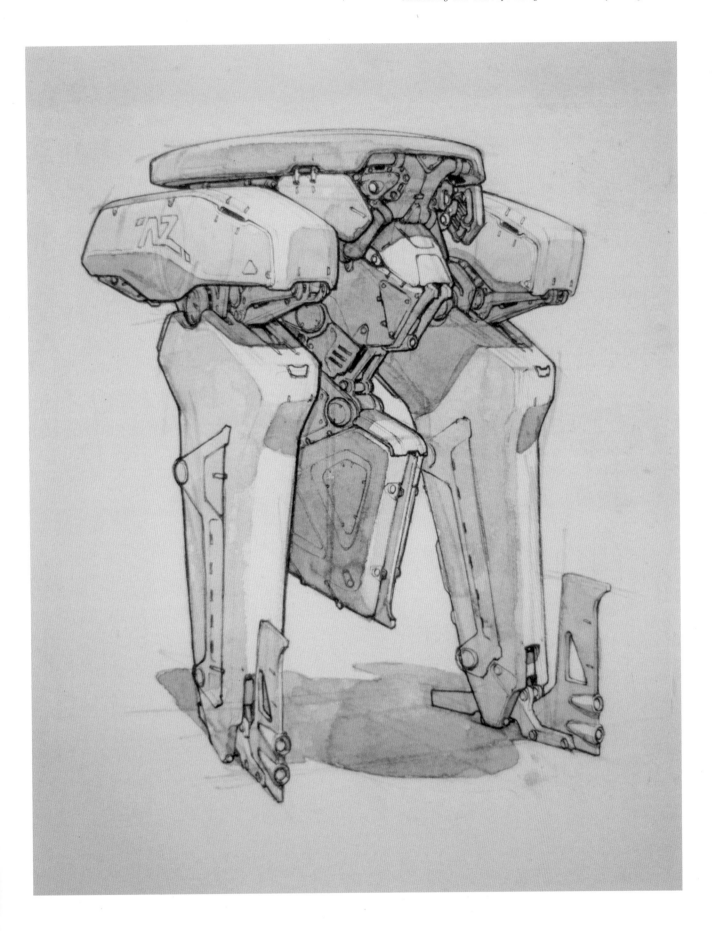

Black backdrop

Adding a backdrop with black ink or paint is a very easy way to frame or compose your design on a canvas, while also providing strong contrast and bringing attention to specific areas of it. Using a geometric shape is an abstract way to create an illusion of space and depth, but use it wisely. In this image, I have enough value and readability on the left side of my design, so that side does not need much of a background. However, the right side has some "light meeting light" surfaces with just a line to separate them. Adding a shape in the background helps to balance my composition on the page, and reinforces the light and shapes, with the added benefit of bringing extra focus to the "face" of the mech.

The final design

The last few touches are the ones to make the design "pop" the most. One thing I often do is introduce a value separation between mechanical elements and cover panels – in this case, making all the inner parts a darker gray than the lighter panels – or sometimes just a graphic design paint job. I choose to do this with a marker, since at this stage there is a good amount of texture and variety coming from the watercolor underneath, and another darker watercolor wash might create too much grain in the shadows. Marker, on the other hand, provides a smooth value change, but still retains the watercolor texture underneath it.

Another small addition is white gouache highlighting on a few key edges. Just a tiny number of highlights can significantly change how an image looks, as they immediately add the suggestion of a second material to the design. If all of the mech's surfaces seemed like a matte material before, now it has a glossy, metallic-looking material as well.

Finally, I add the color accent. In my case, it is a brand or model logo that provides the red-orange color accent, but your accent could be a variety of things: glowing colored "eyes," lights, or even narrative details like blood spots, mold, rust, and graffiti. With that, the design is complete.

Near right: A black backdrop adds focus to the page

Far right: Final image © Nikolay Georgiev

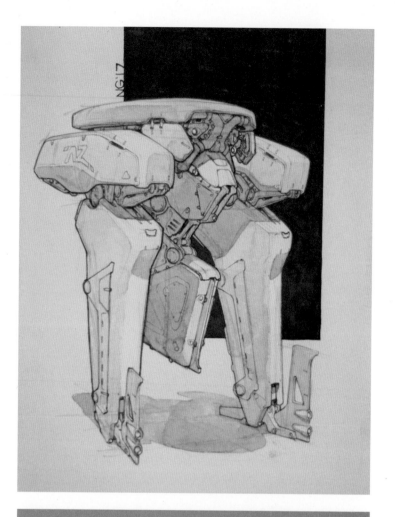

ARTIST'S TIP

Challenge yourself

I rarely design mechs that have obvious weapons, especially as personal work. Of course, in a production environment it all depends on the brief, but I prefer not to rely on weapons when generating my own ideas. I believe that putting a gun on a design is a shortcut to "coolness," which I avoid, since I believe the mark of a successful design is that it can stand on its own and be interesting and "cool" without putting firepower on it. Most of the time I sketch aesthetic-driven designs with kinematics in mind, and sometimes I sketch and design purpose-built machines, such as for construction, demolition, planetary exploration, science, medicine, cargo, and deep-sea exploration. There are so many interesting subject matters that require specific ideation and channeled thinking, that resorting to guns seems like an easy way out. Game development and movies have enough need for battle mechs without spending personal time designing more of them. Always look for a challenge!

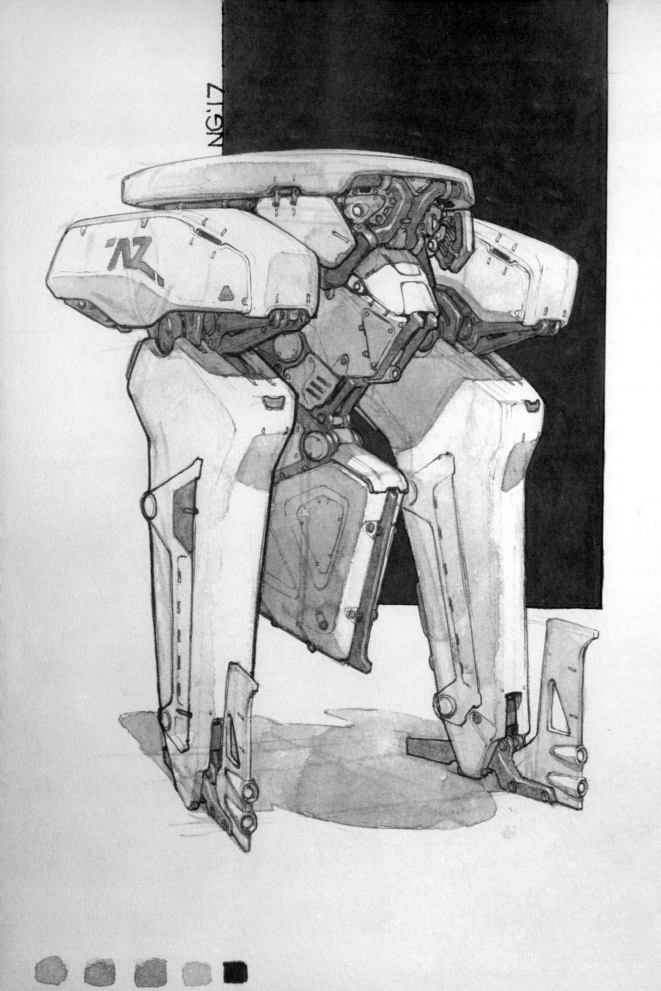

CONTRIBUTORS

Allen Williams
allenwilliamsstudio.com

Ashly Lovett
ashlylovett.com

Anand Radhakrishnan
behance.net/anandrk

Amber Ma
amberma.com

Ulksy
instagram.com/ulksyart

Jason Chan P. L.
instagram.com/onlyparkland

João David Fernandes
joao_david.artstation.com

Nikolay Georgiev
fuelstains.artstation.com

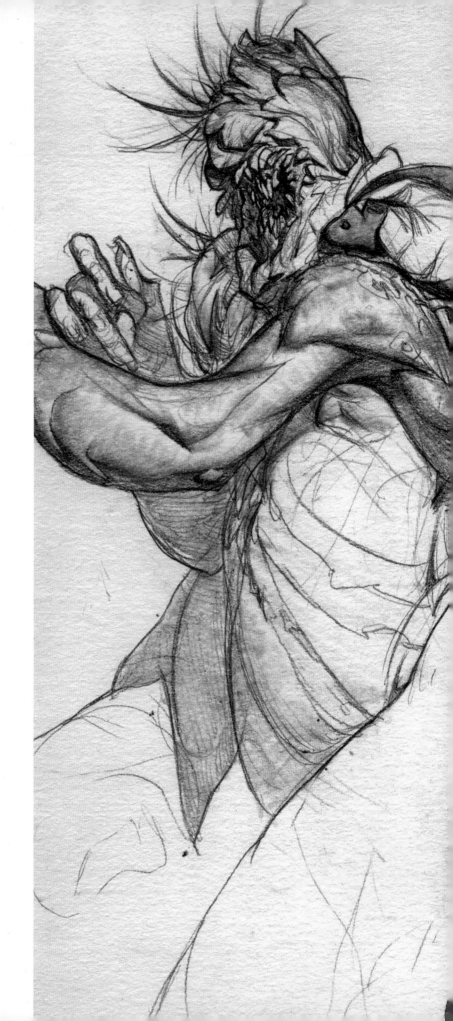

G

THE GRAPHITE TEAM

Marisa Lewis
Editor

Matthew Lewis
Graphic designer

Adam J. Smith
Proofreader and contributor
adamjsmithauthor.blogspot.co.uk

Simon Morse
Managing editor

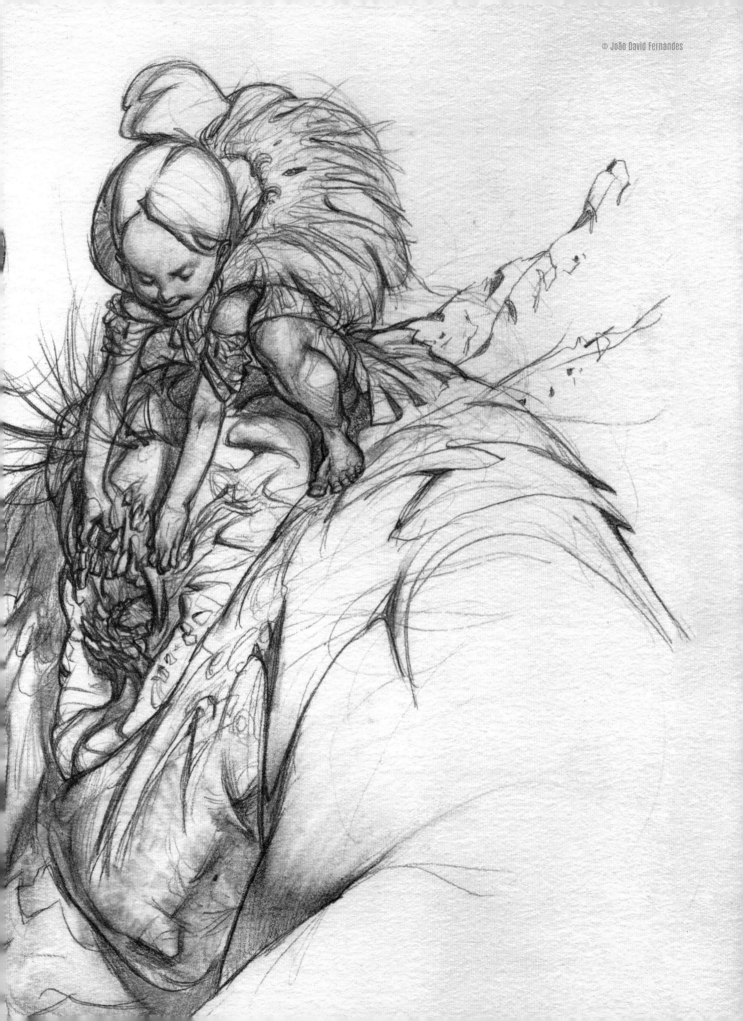